On Cape Cod

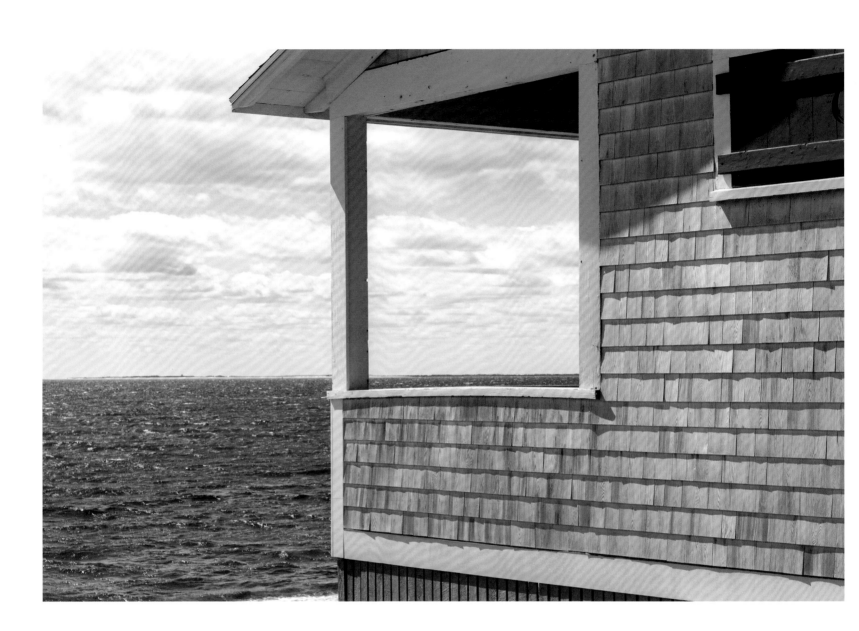

On Cape Cod

Photographs and text by Don Krohn

with an introduction by Geraldine Brooks

David R. Godine, Publisher
BOSTON

For J, Z, T, A, a and s —

"Live in the sunshine, swim the sea,
Drink the wild air's salubrity."

First published in 2016 by
David R. Godine · *Publisher*
Post Office Box 450
Jaffrey, New Hampshire 03452
www.godine.com

Frontispiece: House on the Water, Beach Point, Truro
Endpapers: Sand Horizon, Provincetown Dunes

Special thanks to Bob Korn Imaging.

LIBRARY OF CONGRESS CATALOGING-IN-PUBLICATION DATA
Names: Krohn, Don, photographer, author.
Title: On Cape Cod / photographs and text by Don Krohn.
Description: Jaffrey, New Hampshire : David R. Godine, Publisher, 2016.
Identifiers: LCCN 2015050691 | ISBN 9781567925654 (alk. paper)
Subjects: LCSH: Cape Cod (Mass.)—Pictorial works.
Classification: LCC F72.C3 K76 2016 | DDC 974.4/92—dc23
LC record available at http://lccn.loc.gov/2015050691

FIRST EDITION
Printed in China

Contents

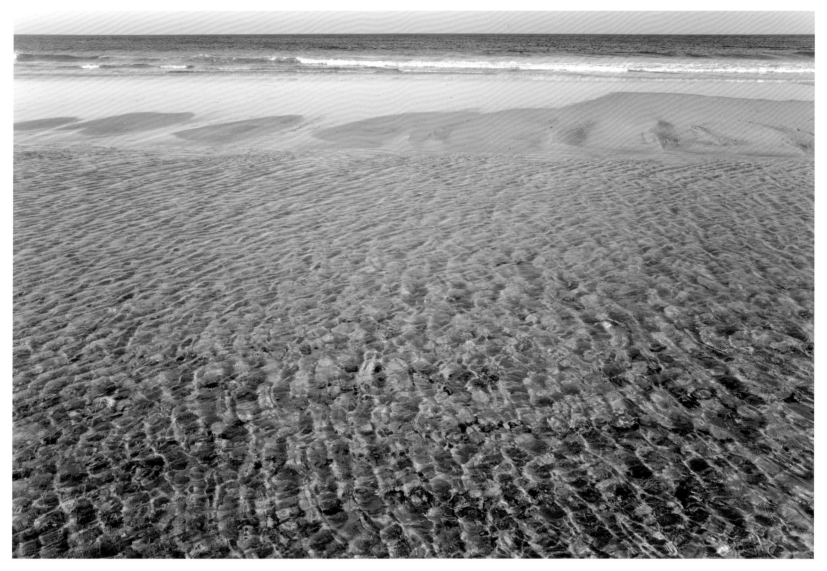

Low Tide at Nauset Beach in Orleans

And I have loved thee, Ocean! and my joy
Of youthful sports was on thy breast to be
Borne like thy bubbles, onward: from a boy
I wantoned with thy breakers — they to me
Were a delight; and if the freshening sea
Made them a terror — 'twas a pleasing fear,
For I was as it were a child of thee,
And trusted to thy billows far and near,
And laid my hand upon thy mane — as I do here.

LORD BYRON, Childe Harold's Pilgrimage

Ah! What pleasant visions haunt me
As I gaze upon the sea!

LONGFELLOW, The Secret of the Sea

I like this place
And willingly could waste my time in it.

SHAKESPEARE, As You Like It

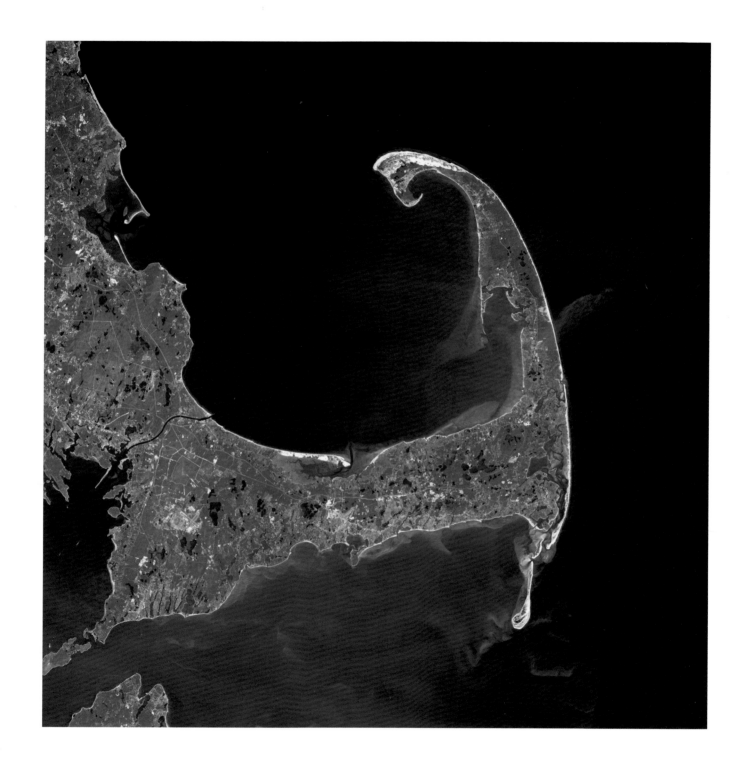

Introduction

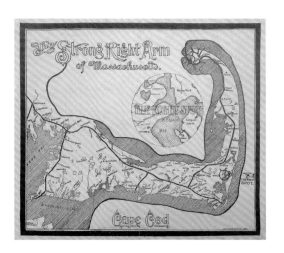

C. Myron Clark, "The Strong Right Arm of Massachusetts," 1899

Henry David Thoreau called Cape Cod "the bared and bended elbow of Massachusetts," and if you ask Cape Codders for directions, often the first thing they'll do is raise one arm in a close-fisted bicep curl. This is not a hostile gesture, just the quickest way to indicate where you are and where on the bent elbow you should be heading.

I first visited the Cape in the late summer of 1983. I was in my 20s, a newspaper reporter, and I'd come to interview a researcher at the Marine Biological Laboratory in Woods Hole. I loved the town immediately: its jigsaw squiggle of coastline, the little drawbridge like something from a child's train set, the busy harbor where pleasure boats moored beside scientific vessels bristling with research instruments. I loved the mix of scientists and seadogs who frequented the portside pubs and cafes, the snatches of overhead conversation that might be about algorithms at one table, the market price of striped bass at the next.

I stayed on for a few days, swimming in the silky waters of Sippewissett, sailing the challenging currents that sluice around the Elizabeth Islands, sitting on the dock and watching sunsets that decked the sky in purple, pink and gold.

Then I boarded one of the big white ferries and crossed the seven-mile channel to the island of Martha's Vineyard. I didn't know then that I would make this crossing many hundreds of times; that two decades later I would buy a home on the Vineyard and become a washashore, as islanders who were born elsewhere are called.

What draws us to a place? What makes us feel at home there? The landscape of the Cape and Islands isn't anything like the one in which I was born and raised. In my homeplace, Australia, the beaches are high-cliffed, rock-ribbed, each one a sharp-carved crescent inscribed between towering headlands.

Here, the beach is soft-edged and indefinite, gentled by undulant dunes. Instead of wind-scoured sandstone, swirls of tawny saltmarsh and sun-silvered grasses mark a mild transition between land and sea. The burning blue of Sydney's sky, the crisp clarity of its arc-light sunshine is here replaced with a watery luminosity, a light aslant and opalescent.

Water defines this land. It's never far away, fingering its way here and there in narrow salt ponds or punctuating the woods in a pearly necklace of glacial kettle ponds. In Wampanoag legend one of these, Witch Pond in Aquinnah, is bottomless. The tribe believes that their hero, the ancient giant Moshup, kept his pet whale there. Swimming in these bracing ponds is like gliding through the cool facets of a crystal. Out in the very middle, treading water so clear you can see your toes, it's easy to believe that the pond might very well be infinitely deep.

The Wampanoag of Aquinnah and Mashpee were not severed from ALL their lands and live here still, keeping these stories vibrant, just as their rhythmic, consonant-rich language hums in the names of the towns, the beaches and the landmarks.

This is a long-settled place, a place of generous abundance. A walk in the woods in almost any season but midwinter yields something good to eat: musky grapes, savory mushrooms, ruby cranberries, blueberries the color of the sky. There are clams for the digging, oysters and bay scallops to be lifted from their briny beds. Waterfowl, fish, venison—it's no wonder the Wampanoag thrived here for millennia. And no wonder some of the very first English settlers saw their future on these shores.

My house was built by one such settler. It's more than two and a half centuries old, a gray-shingled full Cape, austere and unadorned. Sited in a protected hollow, faced towards the maximum sun, it's a sensible dwelling built by frugal, no-nonsense folk. I lay my hands on its huge oak beams and feel grateful for the hard work and skill that shaped them and set them in place without benefit of power tools. As I look out the wobbly panes of its poured glass windows this morning, a tentative winter sun is glimmering on a foot of fresh-fallen snow. An icicle the size of a javelin punctuates the view.

The photographs that follow are not of this subtle-hued, understated season. They depict the ebullience of the summer Cape that's so easy to love, a primary-colored place illuminated by tumbles of beach roses and impossibly blue hydrangeas, glossy-painted dinghies and buoys, bright beach umbrellas and suntanned faces.

Come, they whisper. Cross the bridge. Feel the sun on your back, the sand in your toes. Breathe briny air that has blown fresh for you across hundreds of miles of unobstructed ocean. Adventure to the very edge of your continent. Return to the beginning. Here, on the outermost rim of the land, recall that *Wampanoag* means *people of the first light.*

"Only that day dawns to which we are awake." Don Krohn quotes this Thoreau gem in his closing essay. Cape Cod is a good place to wake up the senses. The photographs in these pages are an excellent beginning.

Cross the bridge, they whisper. Come.

<div align="right">

GERALDINE BROOKS
West Tisbury, January, 2016

</div>

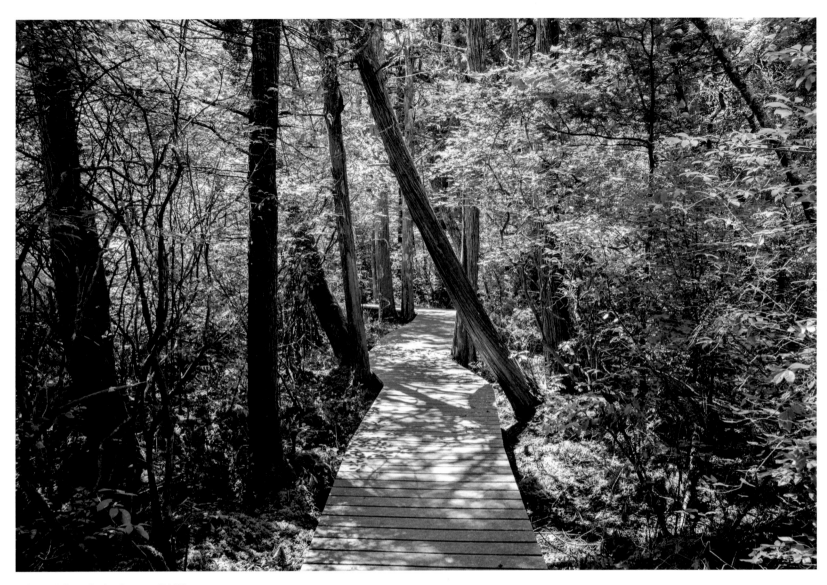

Atlantic White Cedar Swamp, Wellfleet

Photographer's Note

Art teaches nothing, except the significance of life.
HENRY MILLER

Photography is an exacting passion. So much effort is required to get the technical and artistic decisions right, to answer the layers of questions concerning composition, camera angle, format, lens choice, aperture and shutter settings, processing, and printing. And though I have spent decades refining my knowledge of these issues, they are by far the easiest parts of the creative process. They are the variables that are under my control. The vast realm that is not presents the greater challenge: changing light, shadow patterns, a person's expression or movement, the shape of a wave, the time of day, the time of year. Working outside the studio in natural settings, I have limited control over the subject I am looking at, yet I try to see it as acutely as possible and to communicate through my images something about what I see and why I want to photograph it, and thus something about myself. I look for spiritual traces in the world of appearances, elements that transcend the obvious. I lack authority over the subject, whether animate or inanimate; though I exercise creative power, the subject is sovereign.

Consider this, from Russian painter and esthetic theorist Wassily Kandinsky in his essay, "Concerning the Spiritual in Art":

"A work of art is born of the artist in a mysterious and secret way. Detached from him it acquires autonomous life, becomes an entity. Nor is its existence casual and inconsequent; it has a definite and purposeful strength, alike in its material and spiritual life. It exists and has power to create spiritual atmosphere; and from this internal standpoint alone can one judge whether it is a

good work of art or bad. If its form is 'poor,' it is too weak to call forth spiritual vibration. Likewise a picture is not necessarily well painted if it possesses the 'values' of which the French so constantly speak. It is only well painted if its spiritual value is completed and satisfying."

As one of the first abstract painters, he was well served by this narrative of the creative process, which helped guide a generation of modern artists who would revolutionize the creative landscape in the following decades.

I see the photographic medium as a means of expression and connection. If as the viewer you do not feel my presence and have no sense of participation in the making of these images, and if you are not experiencing these subjects along with me, then I have not succeeded in my endeavor. Conformity of perception between us is not my goal, and in fact it is to be avoided if possible. An image may mean something different to each of us. But if the image is to do its job, it must communicate. I am less concerned with imparting a specific message — how am I qualified to tell you how to view the world? — than I am interested in conveying an understanding of my artistic process. This is how I understand Edward Weston's "flame of recognition," the artist's moment of enlightenment and the intense desire to share that excitement.

I cannot recall a time before I began taking photographs. I first used various Kodak Brownie cameras, also some Anscos, but soon after kindergarten moved on to an Argus C3, affectionately known as "The Brick," an early adjustable 35mm camera. The C3's designers somehow missed the advances in ergonomics and modern design of the 20th century up to that point; the era of streamlining passed them by. The sharp-cornered Argus was indeed a brick, but it had a surprisingly sharp lens, whose maximum aperture of f/3.5 was quite fast for the time. The small viewfinder was paired with a clouded, yellow-tinted rangefinder; it was controlled in Rube Goldberg style by external gears driven by a painfully stiff focusing wheel. It was not until years later that I first had the pleasure of working with one of Oskar Barnack's elegant Leica cameras. But none of the oddities of my Argus camera truly mattered to me then; they seemed to be part of the peculiar appeal of the medium I was discovering. I could put in a roll of Kodachrome (film

Kodak Baby Brownie Special, c. 1950

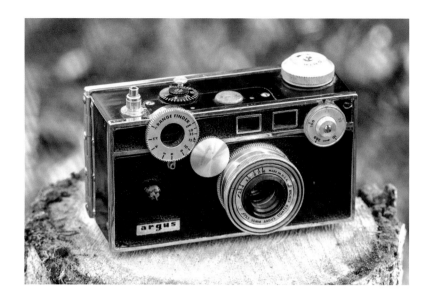

speed 10 at the time) and take a photo of a green hobnail glass vase on a window-sill with sunlight streaming through it, and a week or two later I could squint at a transparent image of that scene as I held it up to the light. That was my reward, a twenty-four by thirty-six millimeter piece of re-purposed movie film in a square of cardboard with the "Processed by Kodak" imprimatur on it.

That particular slide of the vase, which I remember so well and have unsuc-cessfully searched for over the years, had not only documented but also trans-formed the original object. Under the influence of Minor White and other self-conscious meta-philosophers of photography, and in the thrall of Ansel Adams' rigorous zone system, I began to think of photography as revelatory — like Michelangelo revealing the sculpture hidden in a block of Carrara marble — rather than transformative. Either way, whether the medium strips away illusion to reveal a fundamental reality, or simply makes a thing into something else, it is a kind of wizardry.

Early on I sensed that taking photographs was a quest, a path, a process of inquiry. Photography had chosen me to be a supplicant of an unnamed faith, a member of a clandestine society. A committed photographer and true adherent

of this faith, though he or she may take thousands of pictures (many millions, notoriously, in Gary Winogrand's vast and unruly œuvre — and those were on film of course), always knows it is only the image framed in the viewfinder or appearing on the ground glass in the present that matters. A process of revelation occurs in the immediacy of the photographic moment, something exceeding the image-maker's command or comprehension.

It is difficult for me to describe exactly how I photograph a particular thing. I may stand in one spot for an hour, watching the light change, or I may return another day seeking different conditions. But at some point I will know that this is the photograph I am waiting for (unless it turns out otherwise, and I move on), and somehow I will recognize it and use the fraction of a second of exposure to take the photograph. In the not so long ago days of film I would at that point have secured what is called a latent image, hidden safely in the film's emulsion in the total darkness of the camera, waiting to be revealed in the darkroom through chemical processes.

I digress to note my concern for digital photographers (myself now fully among them) who instantly see the results of each photograph. How much of the creative element and unalloyed excitement has been surrendered through the elimination of anticipation and uncertainty? What do today's photographers think when they read Weston's description of racing into the darkroom from the blinding sunlight of Mexico to process his latest sheet of film, and how much is missed in not experiencing the dialectic implicit in the negative/positive process, and in the analogous notion of having to retreat into darkness to reveal what was observed in the light of the world? Not to mention the wonder of witnessing a print come to life slowly in a tray of slippery, odd-smelling developer under the faint orange glow of a safelight. A new mystique is evolving, the silicon wizardry of computers and their masters, but in its bloodlessness I doubt the digital dispensation will ever match the thrill and chance of traditional image processes.

Now I return to the question of the photograph. Composition, contrast, line, and color make up the formal elements of any art school explanation for a picture. But the academy's focus is primarily on technique. The presumed question in any

work of art, in any medium, is meaning. And there is no answer to that question, as it was never destined to be answered. We can discuss what a work of art is about, and how it was made, and these discussions initiate the process of understanding. We may describe a photograph of a particular thing in nature, produced in such as way as to emphasize a certain angularity of form, or a level of contrast, or an interaction of color or texture. But often it seems as pointless to talk about meaning in a photograph as to try to explain a poem. The *raison d'être* for any art form is to communicate things about the world, about people and life, which dwell beyond daily language. We may make declarations about a work of art, but its meaning resists attempts to be translated out of the medium itself. People of course fail in this effort and fear the challenge and pleasure of simply looking. As the photographic pioneer Eugène Atget noted, "Good pictures are not explained by words, and in the case of the best pictures a writer would be well-advised to save his paper." Or as Yogi Berra said, "You can see a lot by just looking."

The composer Robert Schumann observed that the esthetic principle is the same in all creative works; only the materials differ. Thus this way of approaching meaning in art operates across all media and forms. Shakespeare's works are the subject of vast amounts of exposition, and some of what is written helps us appreciate his plays by explaining their historical context, the theater of the time, plot derivation, character development, dramatic values, and analyses of productions. Encountering an actual play elucidates the limits of such analysis. After seeing a performance of *Twelfth Night* — described by Stephen Booth as "one of the most beautiful man-made things in the world" — we can talk about the plot, the setting, the characters and their motivations. We can say it is a comedy concerning love and its attendant difficulties, and that it deals with issues of loss and reunion, identity, deception, gender, and ambition. The more we know about these themes, the better our understanding of the play.

But why are we so drawn into *Twelfth Night*'s "precious nonsense," to quote Booth again, which seems on its surface to be rather slight? What does it mean, and why is it somehow liberating to watch? Shakespeare's unique artistic vision must be understood in an amalgamated language of drama and poetry, in the experience of watching what is a distinct form: a Shakespeare play. And each

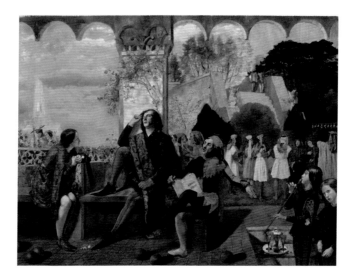

production, each performance, is a new incarnation of the original. The opening
lines of the second scene, simple and yet overwhelming in feeling, are so full of
promise for what will follow:

> *Viola.* What country, friends, is this?
> *Captain.* This is Illyria, lady.
> *Viola.* And what should I do in Illyria?
>> My brother he is in Elysium.
>> Perchance he is not drowned. What think you, sailors?
> *Captain.* It is perchance that you yourself were saved.

I keep trying to solve the riddle of what is so enthralling in that exchange. The
beauty of the Captain's suggestion of salvation stated in perfectly balanced iam-
bic pentameter and the intrigue and promise of new places are integral to the
dramatic construction of the entire work. There is an extraordinary power to
the conversation that I am not able to explain adequately. Here is Dostoevsky
in *The Brothers Karamazov* alluding to something similar: "Much on earth is con-
cealed from us, but in place of it we have been granted a secret, mysterious sense

of our living bond with the other world, with the higher heavenly world, and the roots of our thoughts and feelings are not here but in other worlds." Whether these other worlds are called mystical or heavenly, or simply the everyday, when viewed unclouded by William Blake's "doors of perception," art adumbrates that other plane. We will never come close to understanding our world entirely, neither the evident nor the concealed, but artists attempt (and reattempt) a process of comprehension using special languages. "Art is an experience, not an object," Provincetown artist Robert Motherwell stated. And to attempt to answer what *Twelfth Night* signifies, using ordinary language, the best I can do is recall André Gregory's comment summarizing his bizarre experiences working with Jerzy Grotowski and a company of actors in a forest in Poland: "It had something to do with living." Or we can simply contemplate Olivia's astonished words at the climax of the play: "Most wonderful."

Taking another tack on these issues, consider George Emerson's agitated exclamation in E. M. Forster's *A Room with a View*: "We're alive!" And even though George and his father graciously dismiss the importance of the eponymous view (especially to men) in offering to relinquish their room in the *pensione* in Florence, it is clear that they know the formidable value of such a thing. Forster understands that a view is both an internal matter of the psyche and a visual experience. To be alive is to imbibe the view — the vision — of everything. This is the notion we dare not dwell upon for too long, as we would have no time for the prosaic demands of everyday life. But perhaps thinking of those demands as mundane is itself an illusion. Is not *all* of life — every view we are privileged to have of it — astonishing, and not just the wondrous, but also the difficult, the boring and repetitive, and, alas, the depressing and discouraging? Here we are, each of us a result of millions of years of development, wildly complex creatures about whom our knowledge is incomplete. Our evolution must have included the weeding out of those members of the species who could not suppress constant amazement, those distracted souls having been eaten by wild beasts or having met other unfortunate fates. So of necessity we avert our eyes and thoughts much of the time from the passionate and enigmatic story of ourselves, just as Blake laments that man "sees all things thro' narrow chinks of his cavern."

Yet we do keep part of ourselves accessible to this ardor, and experience this mystery as something fundamental in our lives. We see its presence in powerful and exquisite paintings on cave walls from 17,000 years ago. This grasping at comprehension, meaning, and connection keeps the window open to sensitive artistic endeavors. We hope that artists will share insights about this strange business of life, the complexity of our planet and beyond, something that exceeds what scientists and cosmologists describe with their own elegant languages and models. This is my immodest goal when I squeeze the shutter button on a camera.

All artistic enterprises spring from this part of our being, the sacred portal of the esthetic. Consider the diversity of forms we have developed and refined through the centuries, examples of which include great works that remain undiminished by time. We deride our culture as rampantly materialistic, but where in that narrative do we account for the crowds at museums and performances, or for the love of literature? When I see a celebrated Rembrandt or Leonardo, sometimes I am drawn as much to the people viewing the painting as to the work itself. Even in the haste of life, people stand in moments of calm looking at a few square feet of pigment-covered wood or canvas that has been revered and protected for centuries. What is it about a particular composition that makes people stop and gaze intently? Why do we connect with the human drama of the picture? What induces pilgrimages and quests to see as many of the world's thirty-five Vermeers or six Giorgiones as possible, or to experience countless productions of Mozart or Verdi operas, or to reread every Jane Austen novel each year?

The Romantics and Transcendentalists believed that the natural world is part of the window into the spiritual. We "sightsee," traveling for the purpose of visiting and viewing fascinating places, both natural and constructed. The first landscape painters acted instinctively on the impulse to record what they saw and wanted others to see, sensing the significance of atmosphere, perspective, and viewpoint. This impelled them to take the radical step of carrying the easel out of the studio and into *plein air*. Once photography became available as a way to do much the same thing, photographers were challenged to continue the landscape tradition, while developing a new visual language. Photographers such as Ansel

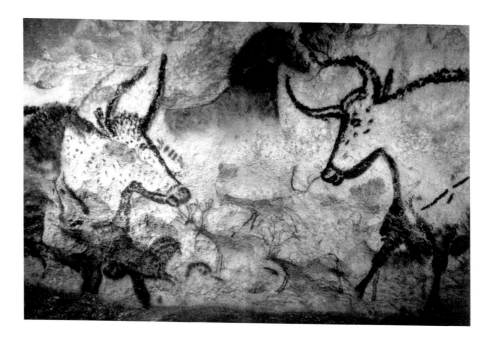

Adams, Edward Weston, and Eliot Porter returned directly to the Transcendentalists' focus on nature as a key to self-understanding and moral guidance.

I like to think of Adams in the American West setting out on arduous trips into the mountainous wilderness, carrying his heavy 8 × 10-inch field camera and tripod in his specially constructed backpack, overcoming all obstacles to experience and document those wild places. Adams in images, like John Muir in words, came closer than anyone has or ever will to describing the vast impenetrability of California's High Sierras. I retain a parallel image in my mind of Emerson or Thoreau in New Hampshire's White Mountains, looking with reverence into the immense Great Gulf Wilderness. These wild places were the palettes for their outsized imaginations. I love my chosen *métier* for the opportunity it offers me to retrace some of these routes, and to find my own, establishing similar connections with the landscape, while seeing and depicting places in my own way. Although not as remote now as they were to those early explorers, some of these holy places still require days of hiking to reach, and that difficulty adds to the allure, intensifying the desire to apply my eye and camera to the task.

I travelled once from Venice to Padua to see Giotto di Bondone's fresco decoration of the Scrovegni Chapel, the most important masterpiece of the early Italian Renaissance. What did I wait in the sophisticated decontaminating airlocks to see? For one thing, a famous azure sky, something previously unknown in art. But even more importantly I saw — just as I had expected but still could not adequately prepare myself for — the wonder of those three-dimensional people he created stepping unhesitatingly into a new world, artist and subjects together leaving behind the two-dimensional space of Byzantium. As 19th century English critic John Ruskin said of Giotto, "He painted the Madonna and St. Joseph and the Christ, yes, by all means . . . but essentially Mamma, Papa and Baby." From the year 1305, there it remains for us to see, an inexplicable display of genius preserved over centuries through much effort and significant luck. It is a magisterial work which defied the confines of history to shake off everything previously thought about painting, and indeed, about seeing. The Black Death halted his revolution for half a century, to be taken up again by others in the full flowering of the Renaissance.

When I was young, I called myself a freelance photographer, not knowing precisely what the term "freelance" meant: perhaps something medieval or mysterious or risky. I connected it to the idea of being a private investigator, someone ready to make sense of challenging circumstances. Part of me still wants to be Dashiell Hammett's Sam Spade when I am roaming with my camera. Photography *has* turned out to be a career of investigation — of myself and of everywhere I go. Photography is also a career of navigation. I go places to take photographs and to find my way in the world. Pilots learn to navigate above terrain by seeking out the three Rs: rivers, roads, and rails. The Rs are particularly useful because they lead somewhere and come from somewhere. The photographer is similar to the airman, using the features of the world to make sense of it, steering a proper course and staying oriented in an occasionally bewildering landscape.

This business of orienting one's self in the cosmos is our task in life. The Elizabethans, emphasizing their Renaissance desire for non-theological understanding and rational clarity, were intrigued by the conceit that humans occupied an ideal midpoint in size between the smallest and largest forms in the universe. They were approximately correct about our position on such a continuum if,

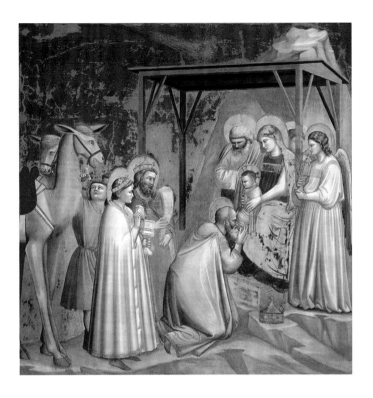

as is proper, we use a proportionate scale to compare. (An absolute measure would leave us appearing almost indistinguishable from the smallest particle.) The Elizabethans' error, and one which would delight them to know, is that both extremes lie ridiculously beyond what they imagined. Their scientific knowledge and the limitations of their tools could not provide them with the means to imagine either the smallest subatomic particles or the vast scale of the universe. They were in fact only beginning to grasp the dimensions of Earth itself, as Renaissance explorers began to map it, while astronomers were expanding their understanding of the heavens, as, for example, Galileo discovered the moons of Jupiter. His revelation, using a ten-power telescope, is probably history's most famous observational experiment, and anyone with a nice pair of binoculars can easily and enjoyably replicate his discovery. Human beings were beginning, at a suddenly accelerating rate, to find their place in the immense scheme of things.

Artistic endeavors build community by allowing us to share experiences. "Only through art can we emerge from ourselves and know what another person sees," Marcel Proust wrote. Words like communication, community, and communion all derive from the Latin *communis*, meaning common, universal, public. A wood-framed black-and-white photograph of the lower Manhattan skyline showing the twin towers of Minoru Yamasaki's World Trade Center was attached to the fence along the Brooklyn Heights Promenade shortly after the 2001 attacks. It remains there to this day, exposed to the elements and uncurated, somewhat faded and stained, expressing itself in heartbreaking eloquence. Art brings spiritual knowledge to our community and sustains our fundamental humanness. Leonardo said that art requires that the spirit must work with the hand. Crowds at museums and historic sites, at operas and plays, gather to see these products of the spirit and hand, gifts from the human community to itself.

Through his statement that "The most beautiful thing in the world is, of course, the world itself," the poet Wallace Stevens has been my imagined artistic counselor. I have long felt an affinity with him, though I refrain from comparing our talents. Like me he was educated as a lawyer but never took the bar exam, and also like me, he accepted and took pride in temporal work, in his case at the Hartford Accident and Indemnity Company, ultimately becoming vice president. I picture him as a quiet dharma master, carefully and honestly doing the work the world requires by day and returning home in the evening to write, his fame and genius unknown to most of his coworkers. He insisted on noting his insurance work in biographical descriptions, and he turned down the prestigious offer to be Harvard's Charles Eliot Norton Professor of Poetry so that he could continue his work at "The Hartford." Perhaps he knew that his poetic powers would function best indirectly and incidentally. Could he have decided to sit before a typewriter in order to take on the "job" of writing "Thirteen Ways of Looking at a Blackbird"?

This idea of the beauty of the "world itself" is what keeps the photographer always seeking things to photograph. I turn again to Atget, as I consider him the first to embrace this belief unequivocally. One senses it instantly while looking at

his pictures, his excitement in realizing that an endless array of subjects awaited him, the radicalism of his invigorating openness to the world. He photographed whatever interested him: shop windows and mannequins, old doorways, itinerant merchants, the scenic effects of light and weather, street scenes of Paris, pastoral images of suburban Saint-Cloud, even the rag-picker with his overburdened wagon. He inaugurated modern photography, appreciating the medium's ability to find significance and meaning everywhere. In an almost Giotto-like leap into a new visual dispensation, he merged the sacred and the profane, creating a bridge to the world we are familiar with today. Atget would have smiled knowingly at Stevens' tautology concerning the world's beauty, and at times I felt those two masterful guides nearby as I created these Cape Cod photographs.

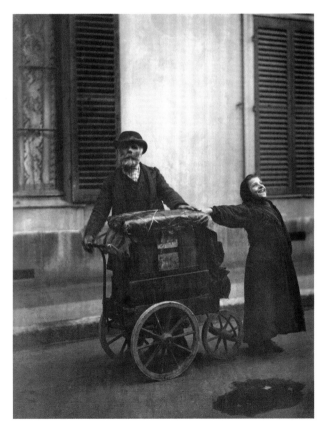

Atget,
"Organ Grinder,"
c. 1900

The Photographs

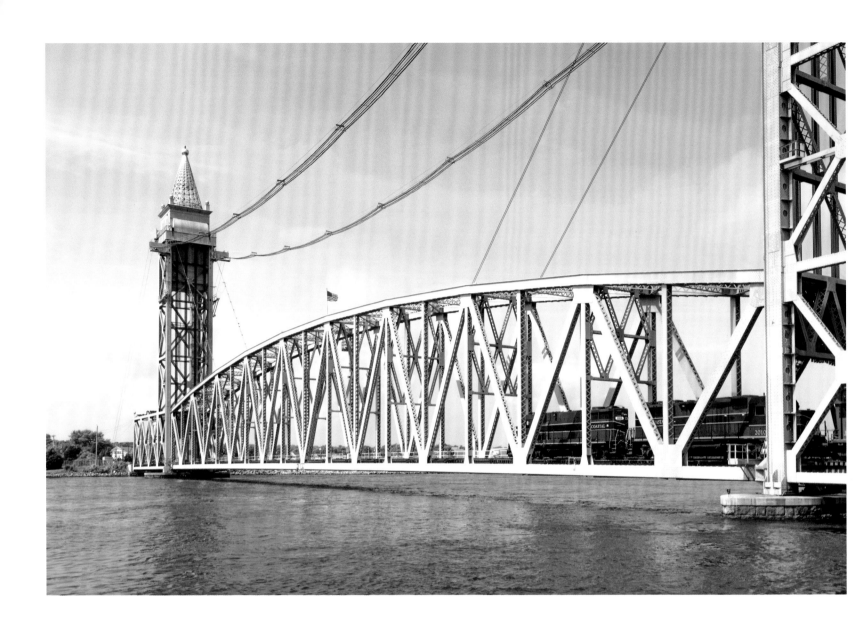

28 Cape Cod Canal Railroad Bridge, Bourne

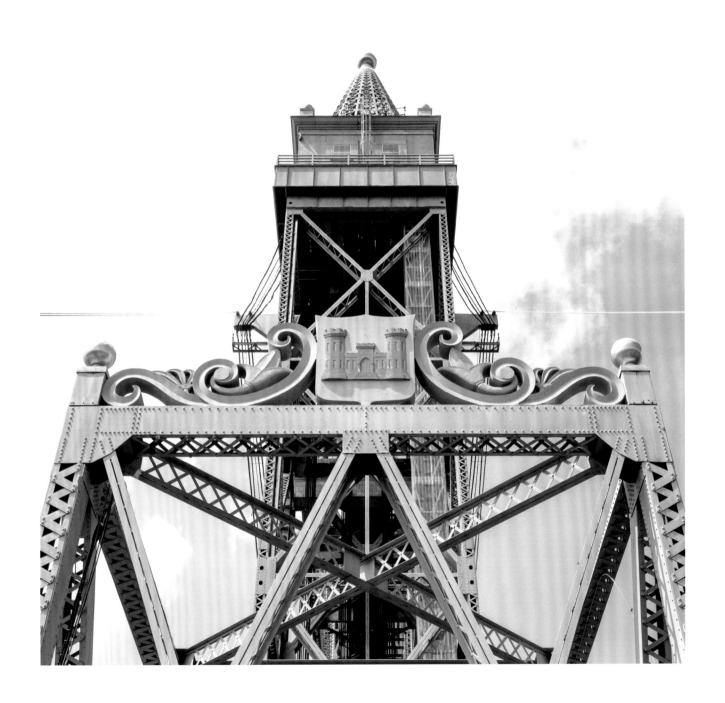

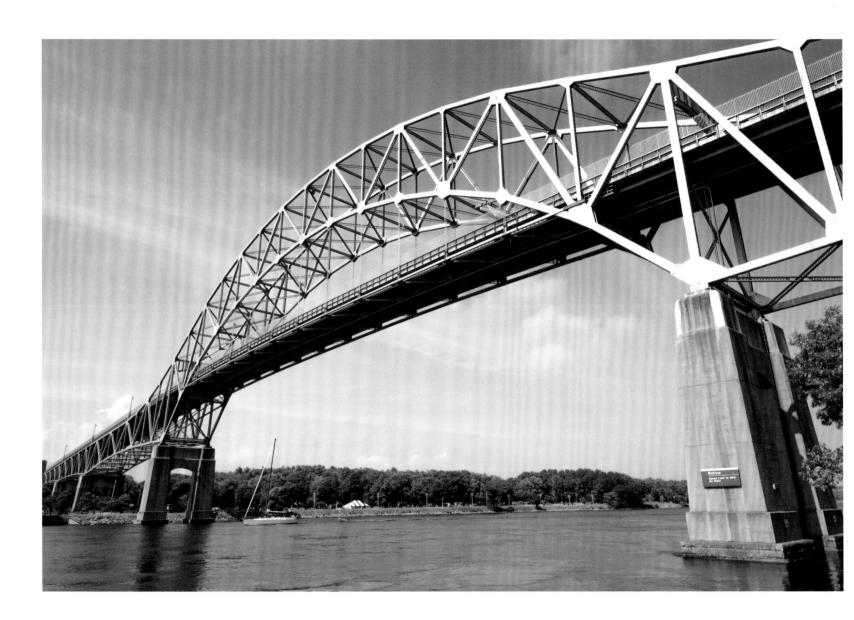

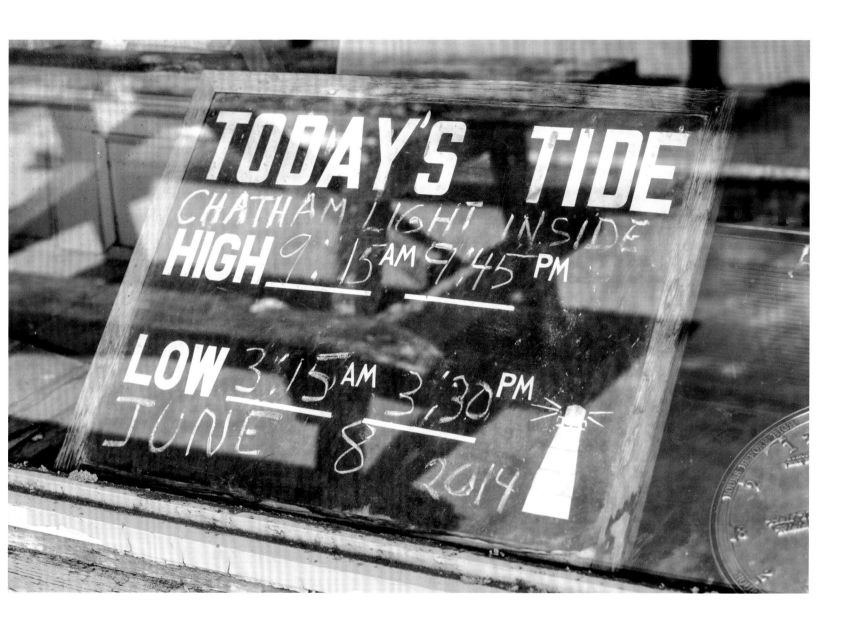

32 The Back Porch at Sea Call Farm, Orleans

34 Slow, Wellfleet

36 Sandals, Lecount Hollow Beach, Wellfleet

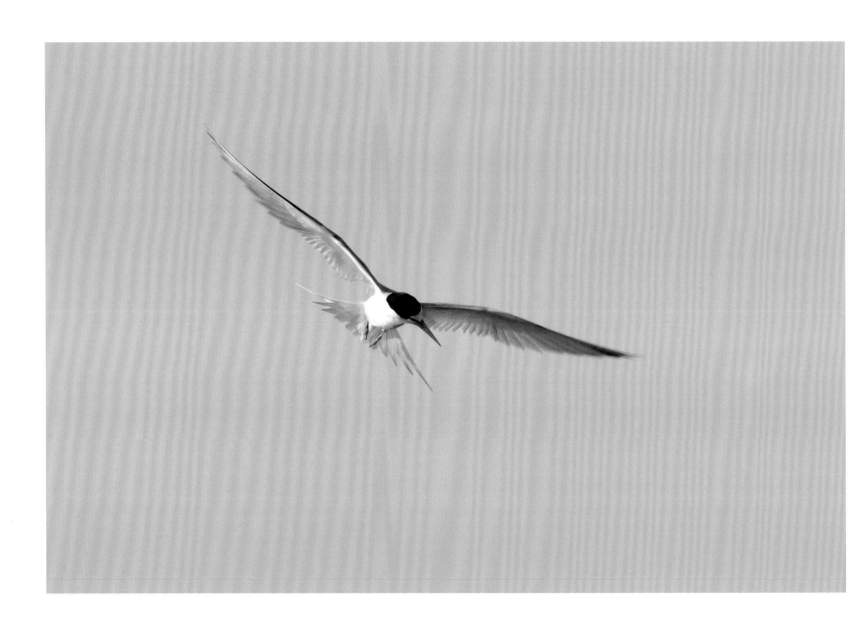

38 Least Tern in Flight, Truro

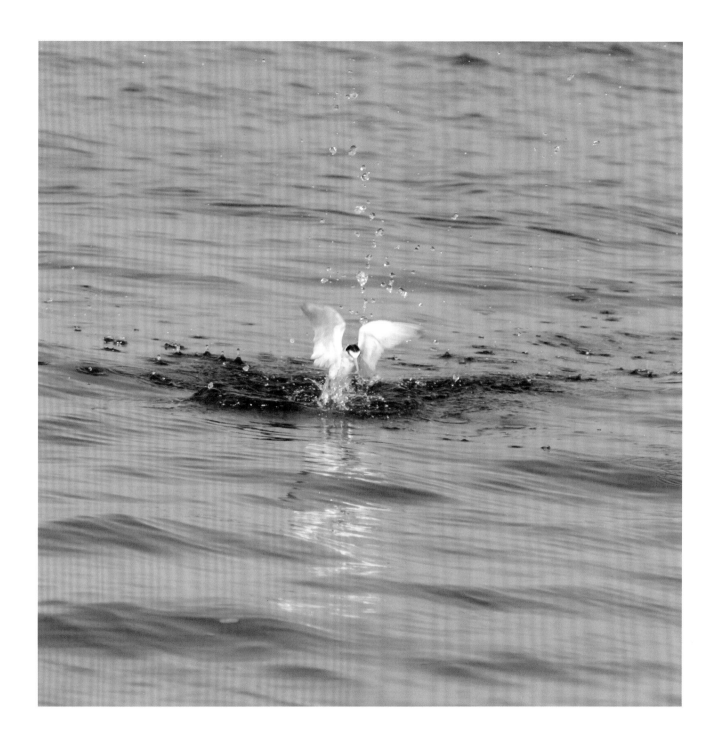

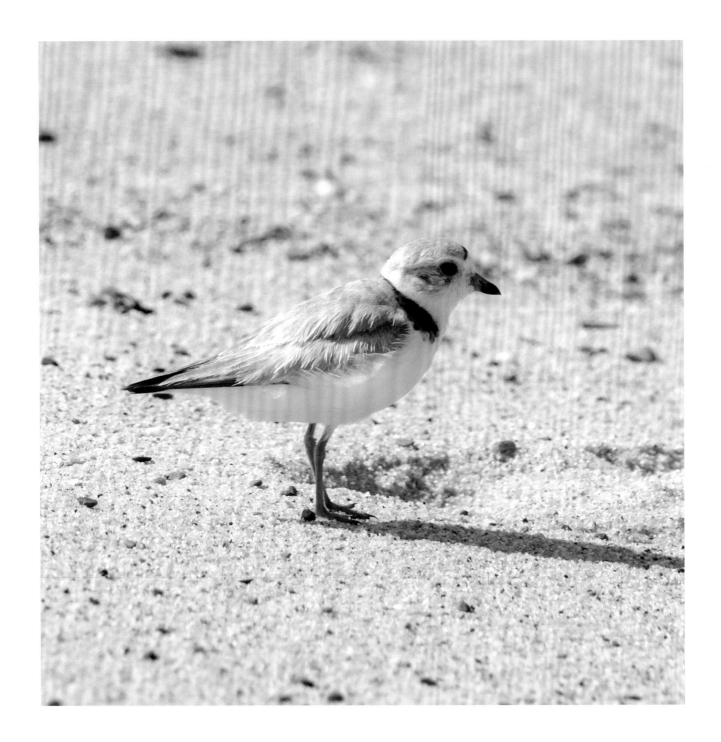

40 Piping Plover, Truro

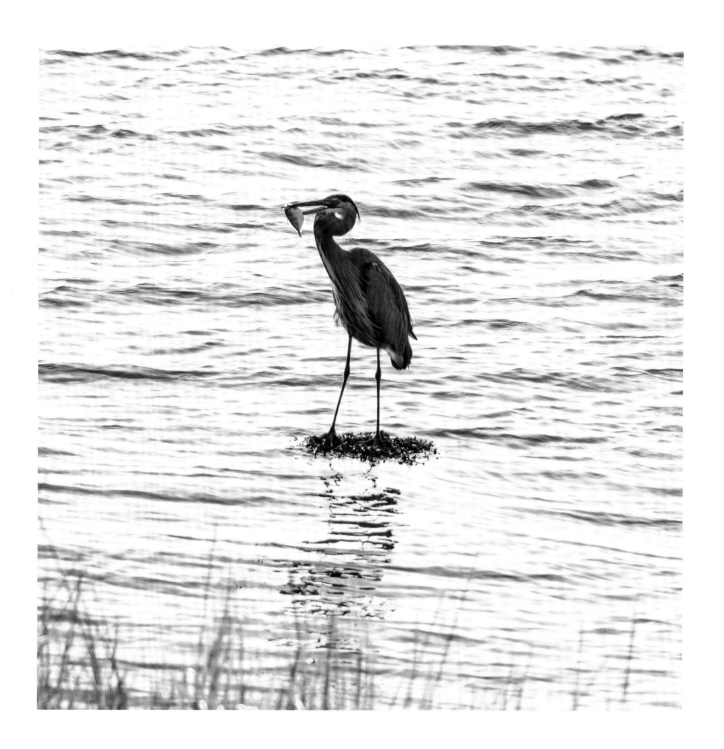

Great Blue Heron with Pogie, Orleans 41

42 Greater Yellowlegs, Yarmouth Port

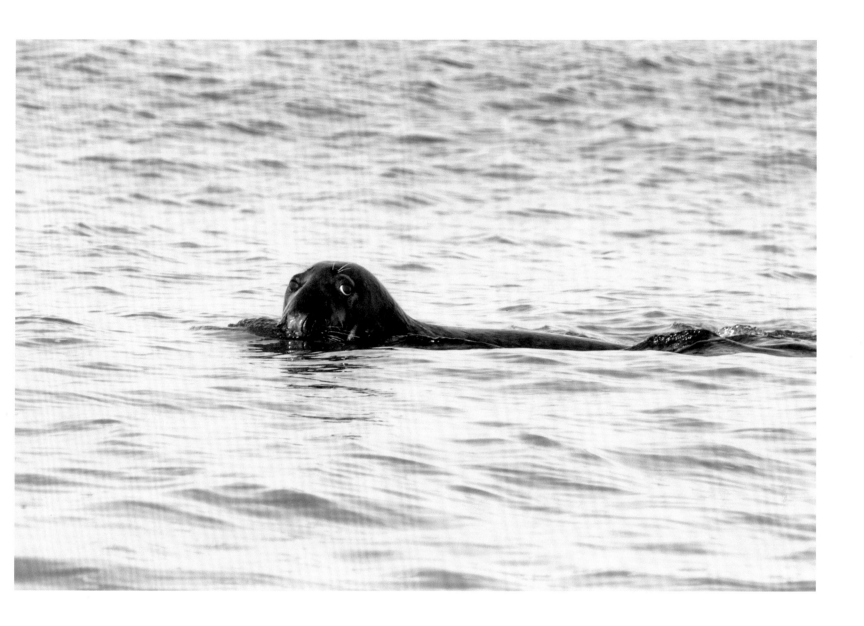

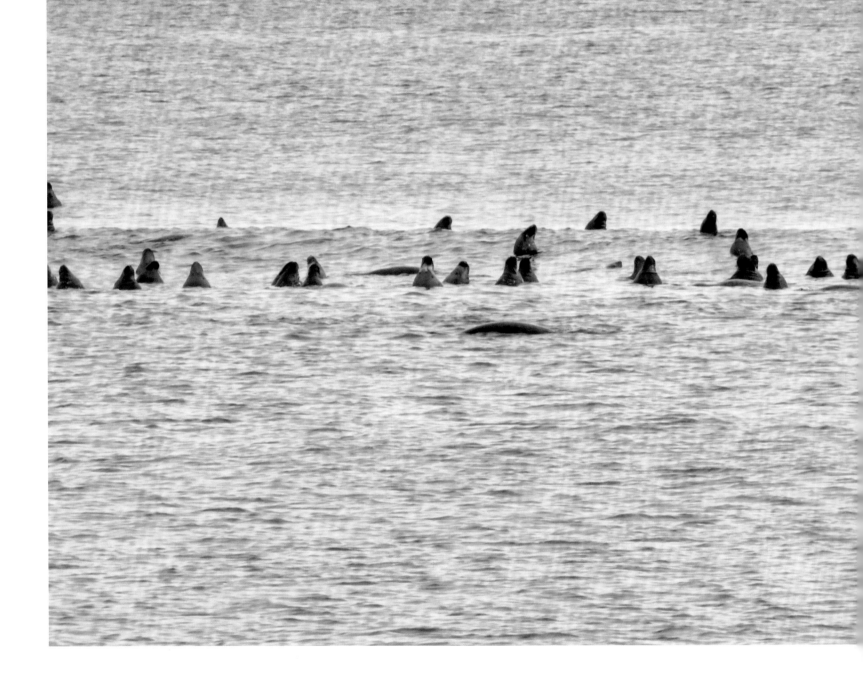

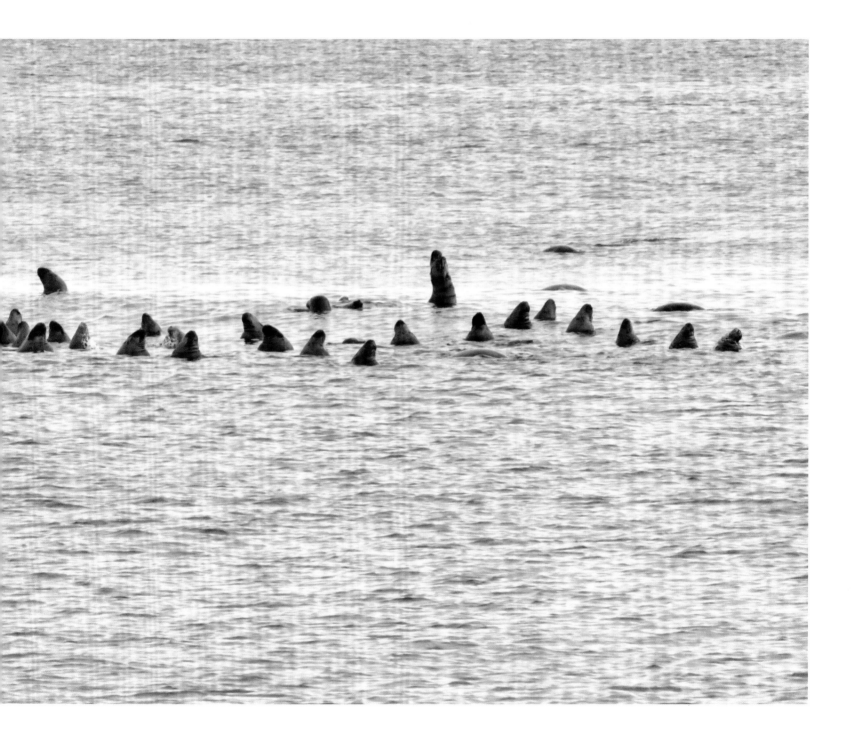

46 Bay View from Truro

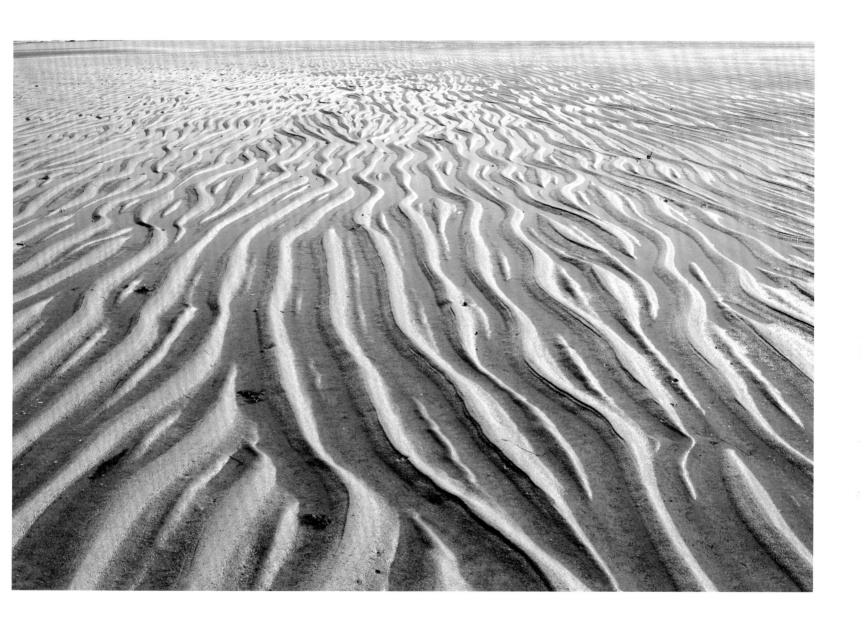

Receding Sand Pattern, First Encounter Beach, Eastham 47

48 Beach Stones, Dennis Port

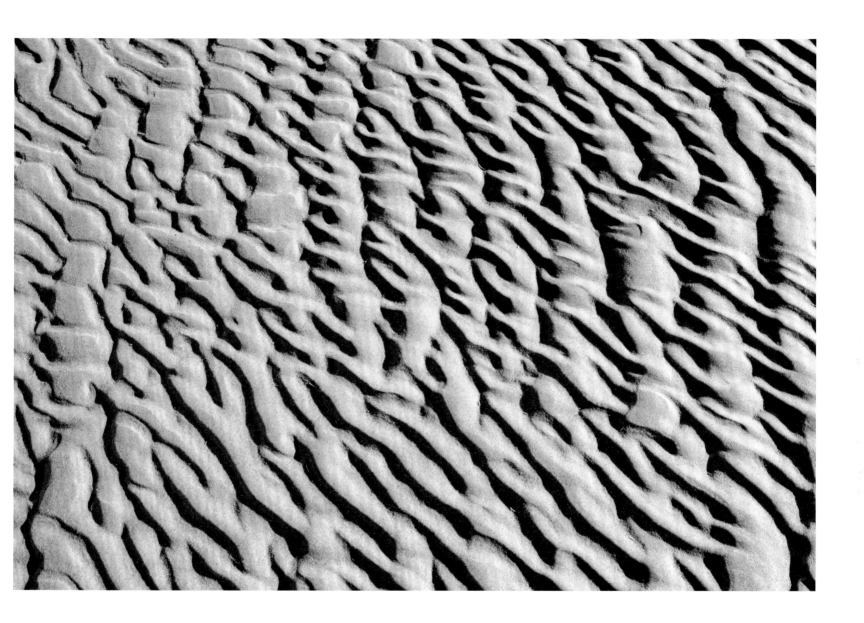

Braided Sand, Breakwater Beach, Brewster 49

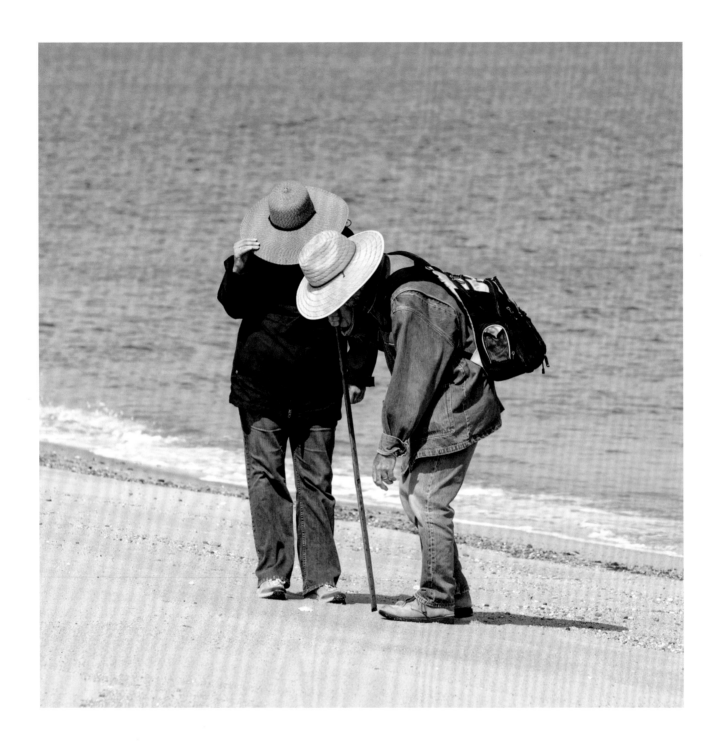

50 Beachcombers, Race Point, Provincetown

Digging Dog and Surfer, Nauset Beach, Orleans 51

52 Mackerel Sky, Harwich

Surfcaster with Striped Bass Tattoo, South Cape Beach, Mashpee 53

54 Sand Sculpture, Skaket Beach, Orleans

56 Low Tide at Skaket

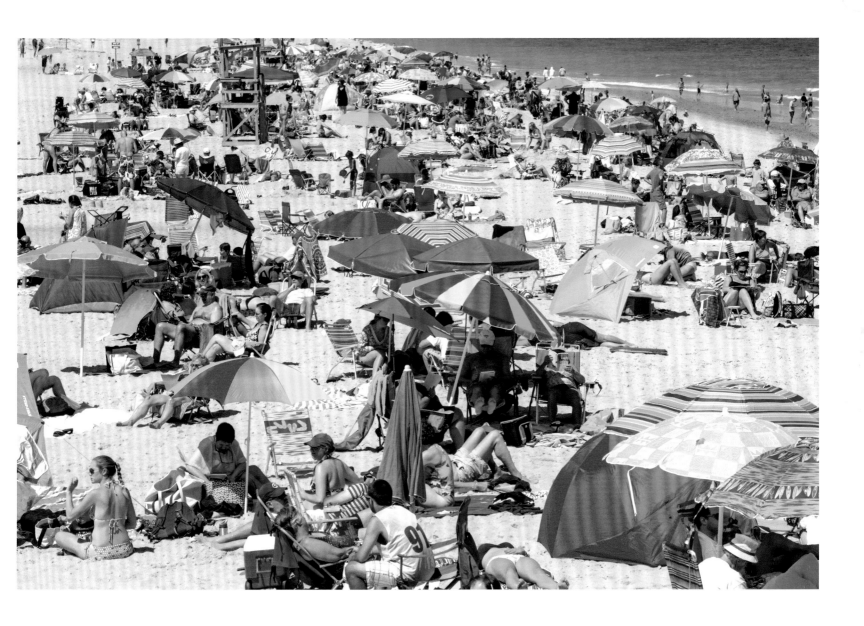

58 Decorations at Cap't Cass, Orleans

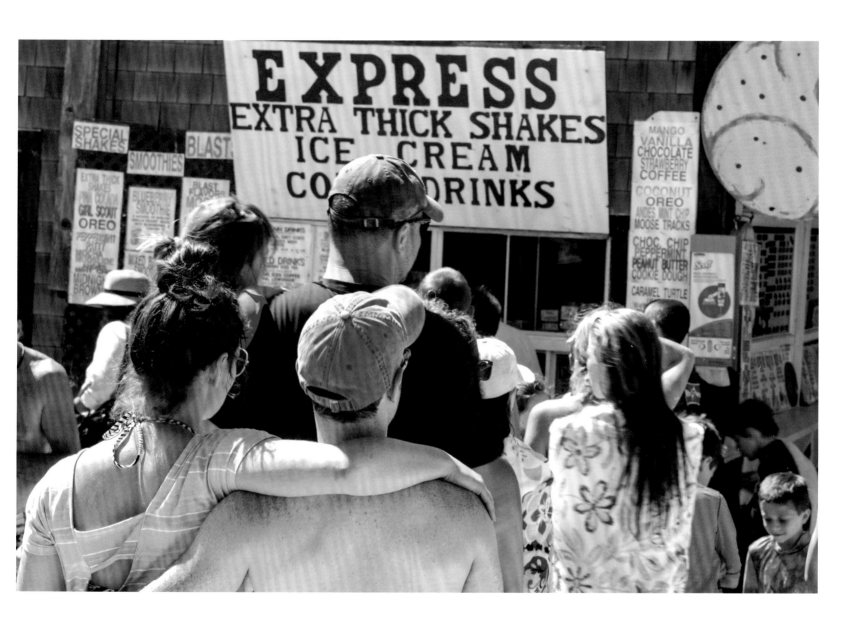

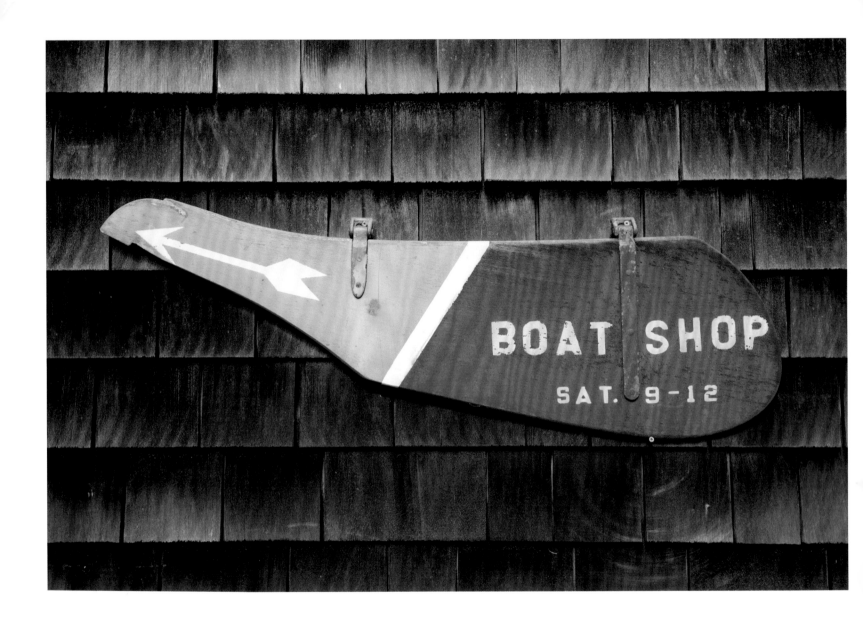

60 Rudder Sign, Woods Hole

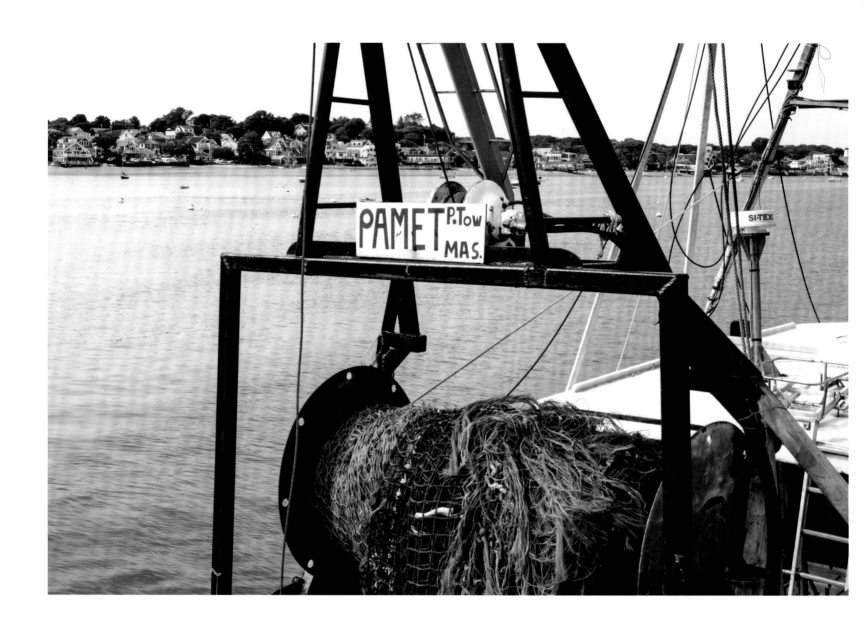

62 Boat Detail, Provincetown

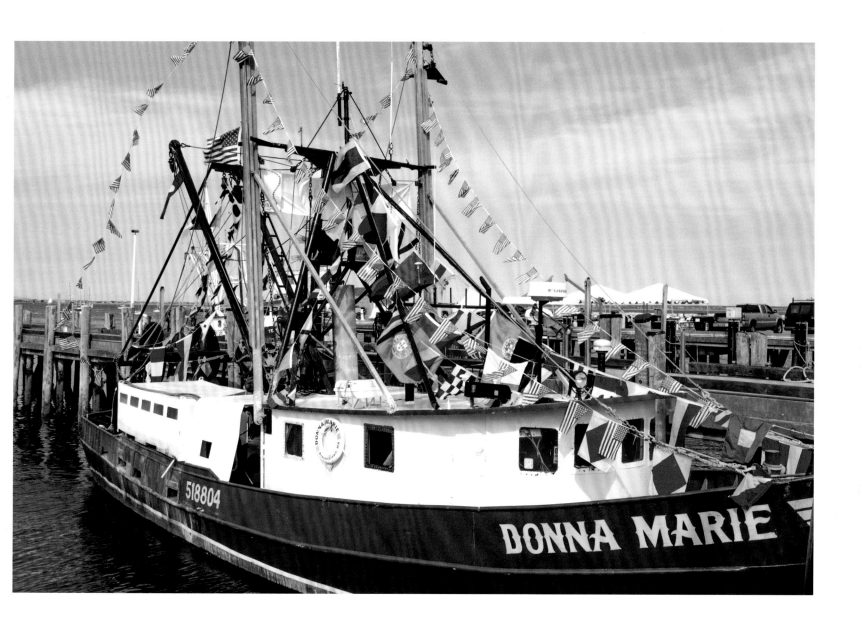

64 Cat Gathering in Pleasant Bay, Orleans: Approaching the Narrows

66 Sailboat Hull Detail, Woods Hole

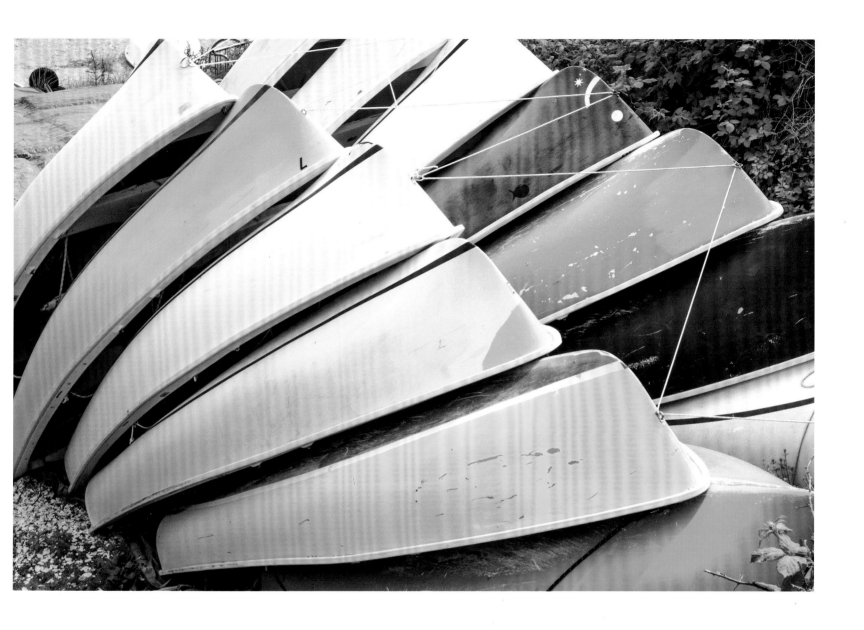

68 Roses and Patched Dinghy, Chatham

Abstract Boat Bottom Study, Chatham 69

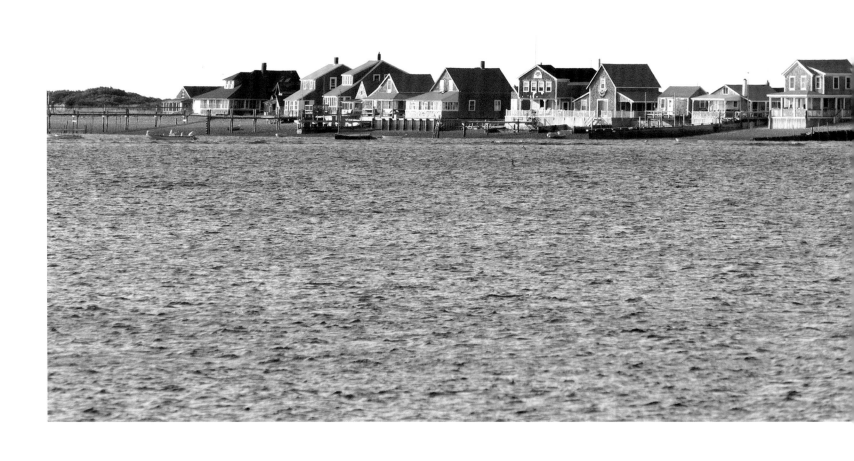

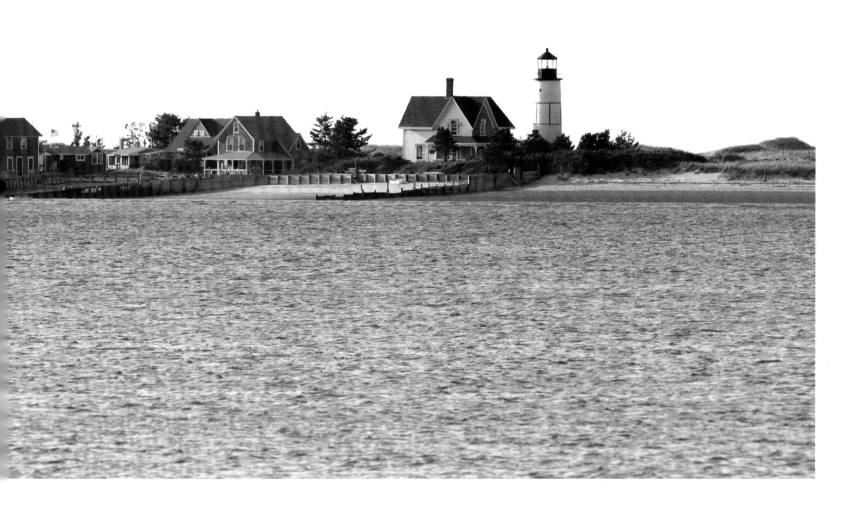

72 Research Area, Parnassus Book Service, Yarmouth Port

74 Window of Packet Antiques, Brewster

78 Signs, Wellfleet

80 Atwood House Window, Chatham

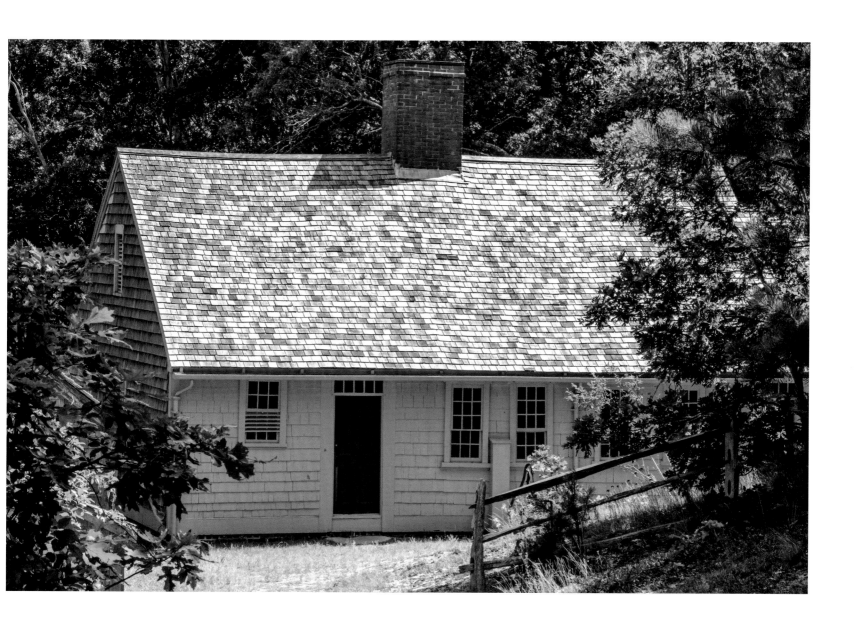

82　Ladles, Green Briar Jam Kitchen, Sandwich

84 Windowsill Bottle Collection, Orleans

86 Ocean View, Old Harbor Life-Saving Station, Provincetown

88 Surfboat, Old Harbor Station

92 Dooryard in Orleans

94 Lady Ferns, Heritage Gardens, Sandwich

96 Peony Blossom, Osterville

98 Provincetown Causeway

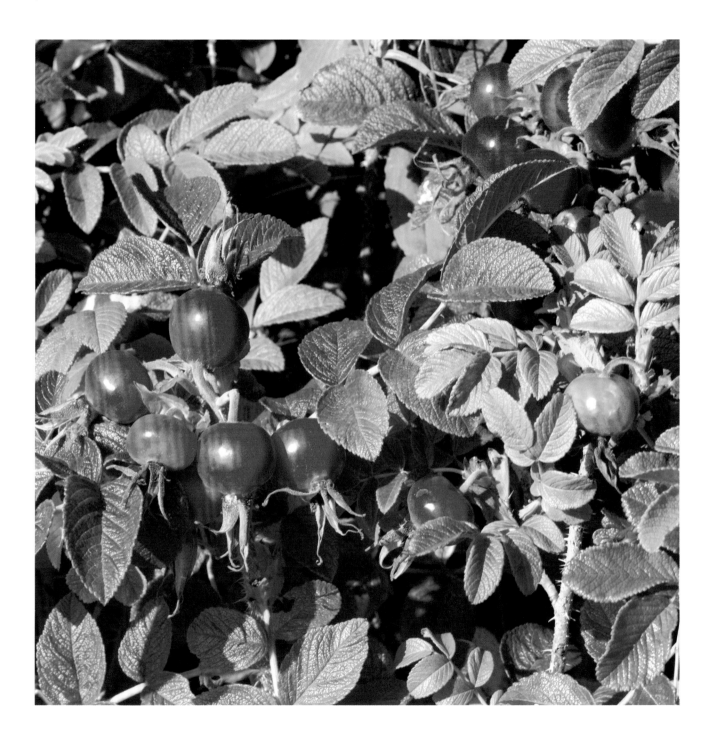

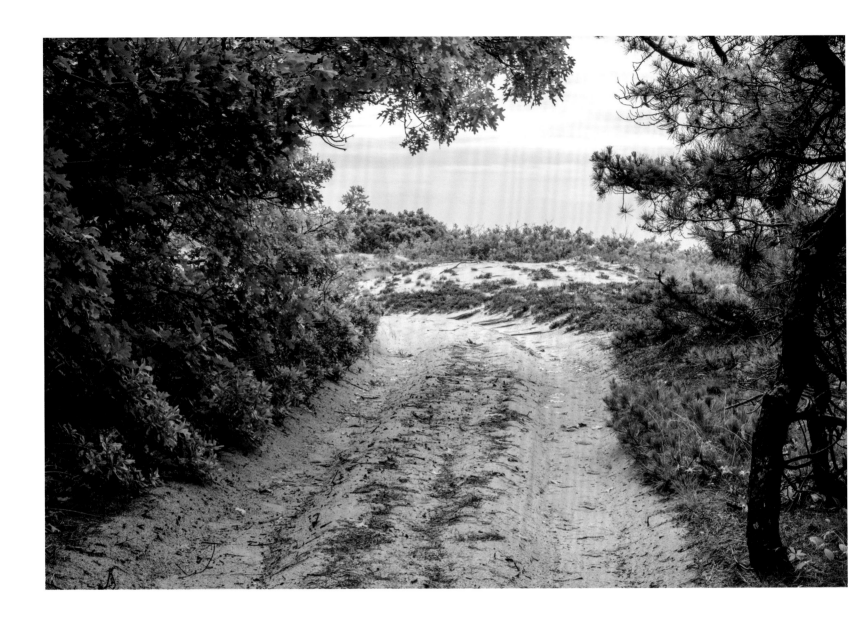

100 Dune Track, Provincetown

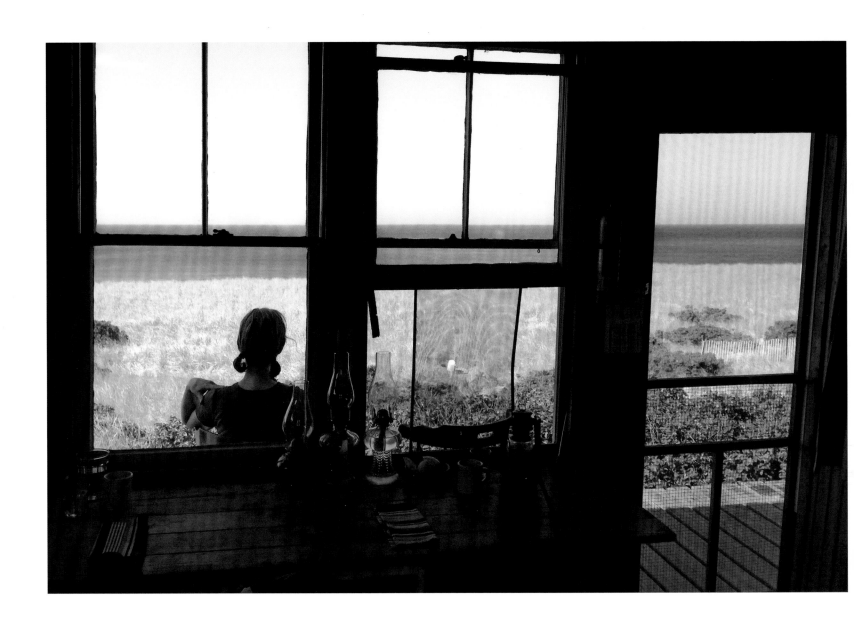

102 View From Inside Boris's Shack, Provincetown

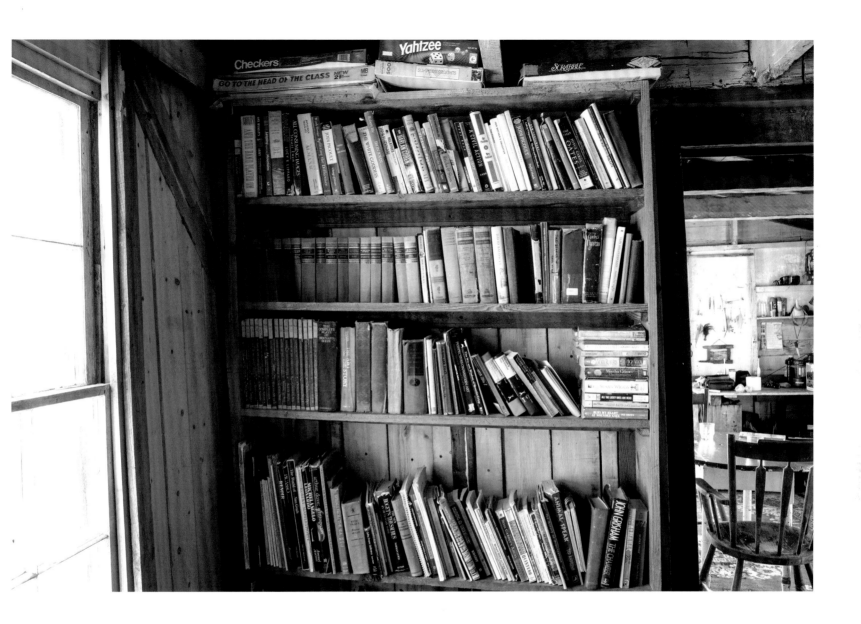

Library, C–Scape Shack, Provincetown 103

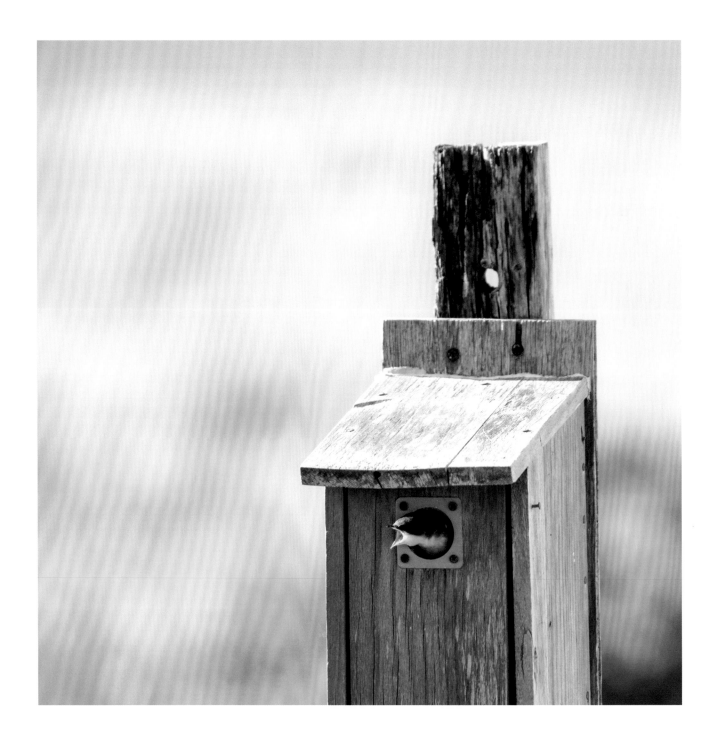

104 Hungry Tree Swallow Chick, Boris's

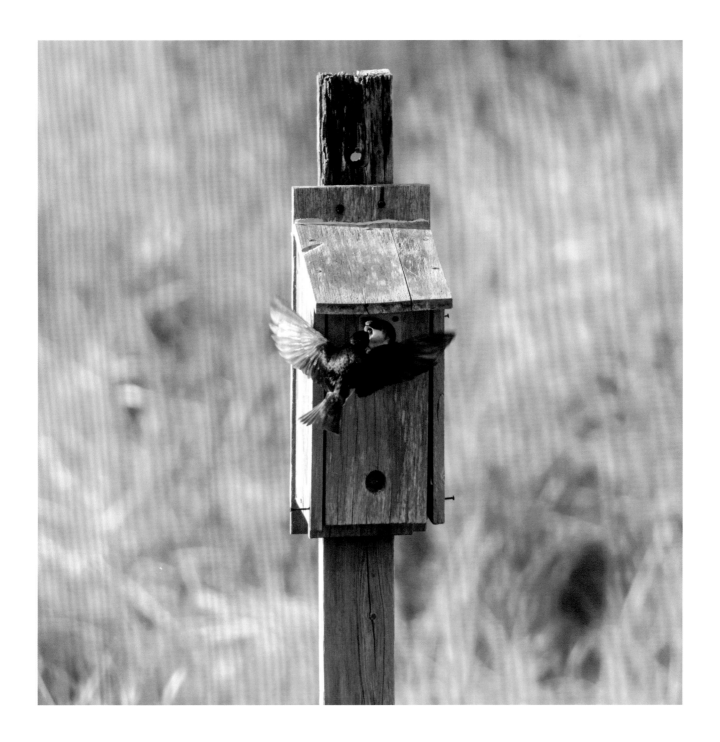

108 Painter's Stool, C-Scape

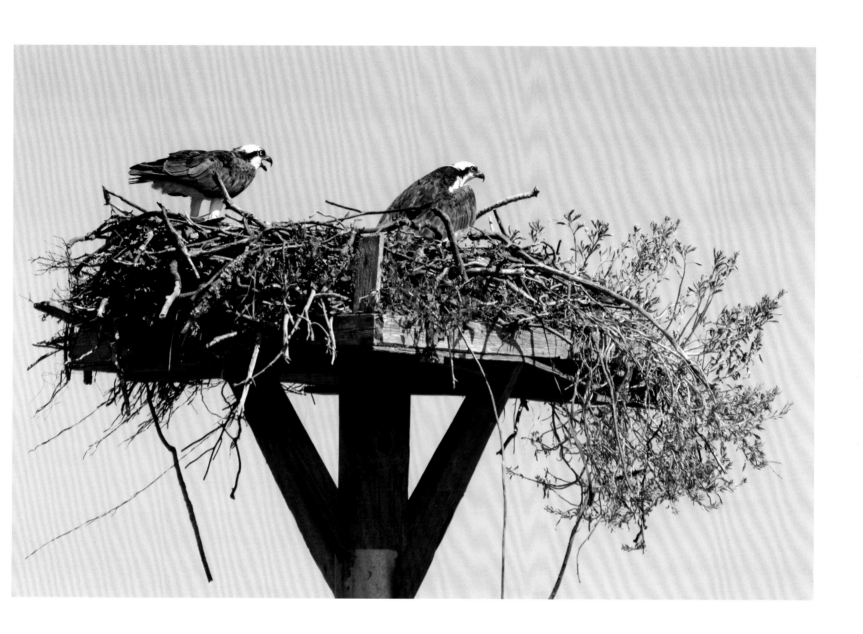

112 Tidal Marsh, Bell's Neck, Harwich

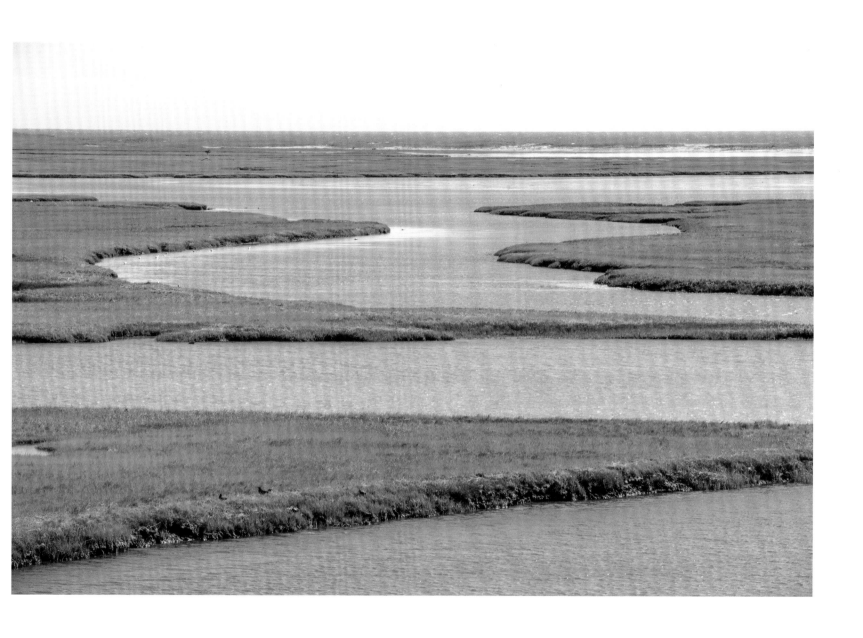

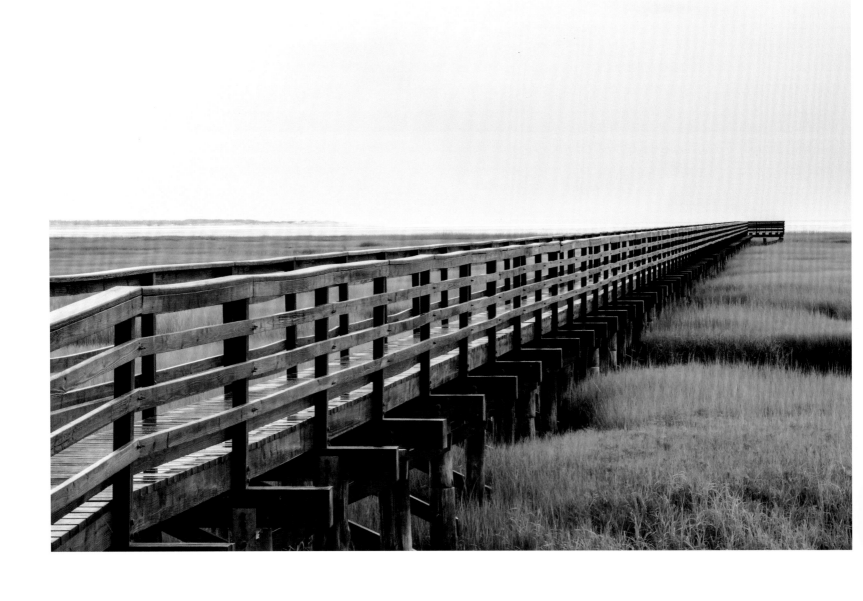

114 Bass Hole Boardwalk, Yarmouth Port

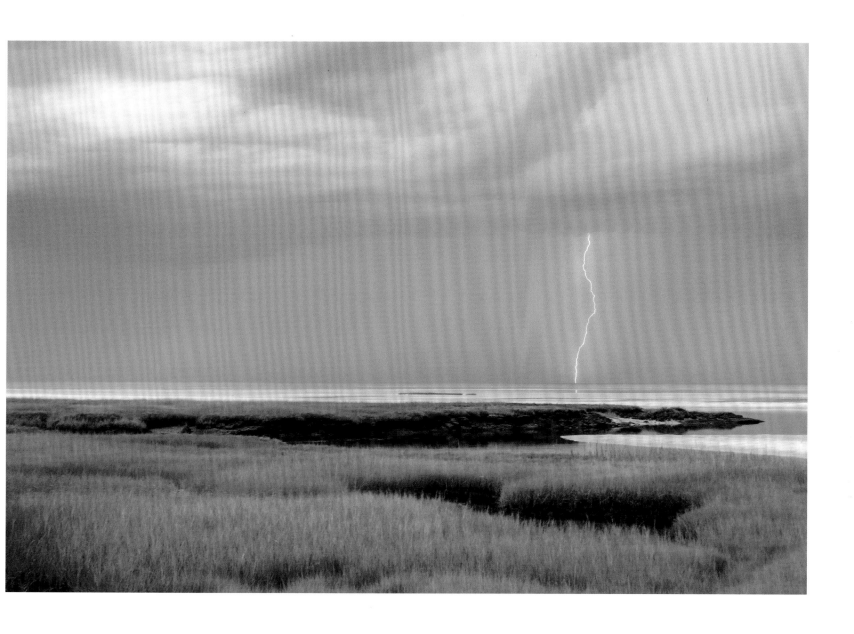

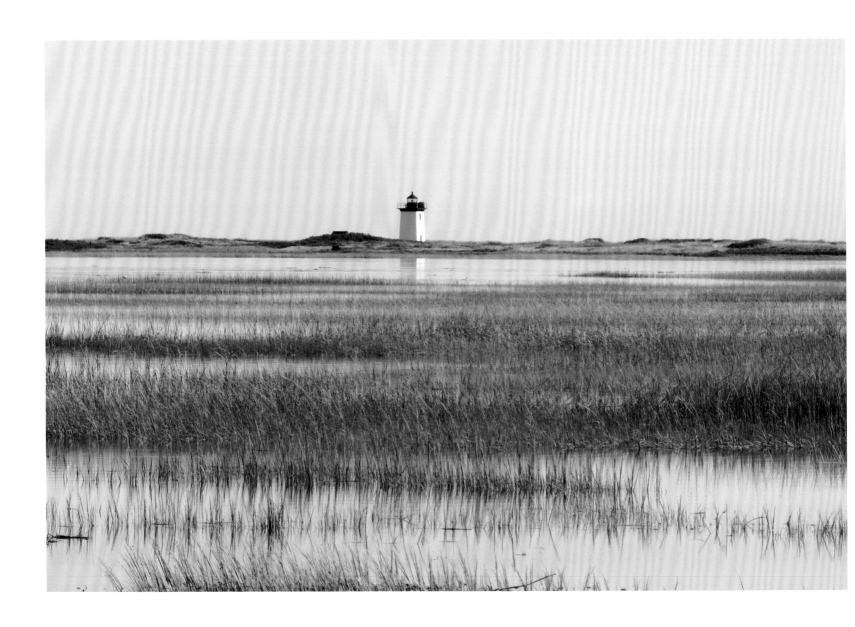

116 Marsh View of Wood End Light, Provincetown

Dune Landscape, Provincetown 117

118 Joe-Pye Weed, Eddy Sisters Trail, Brewster

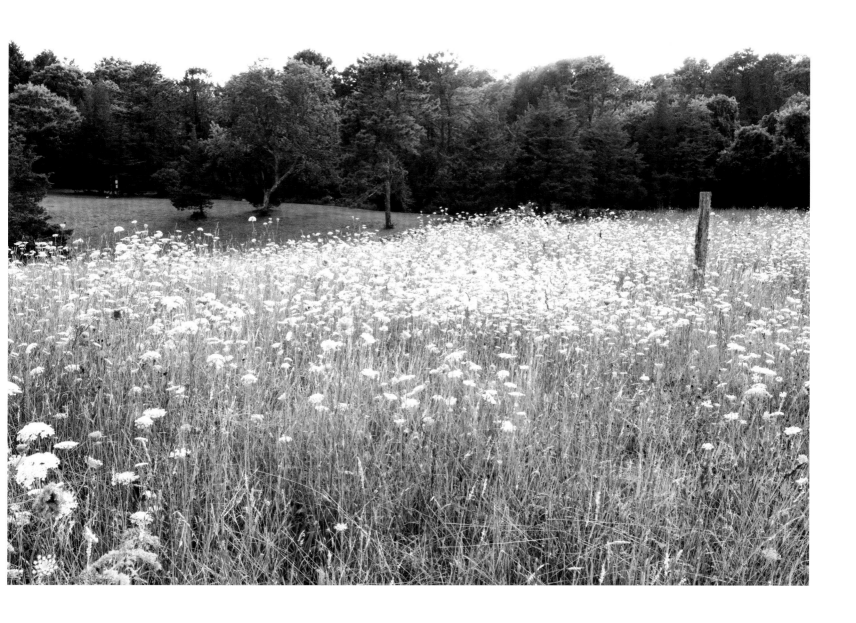

Field of Queen Anne's Lace, Bourne Farm, Falmouth 119

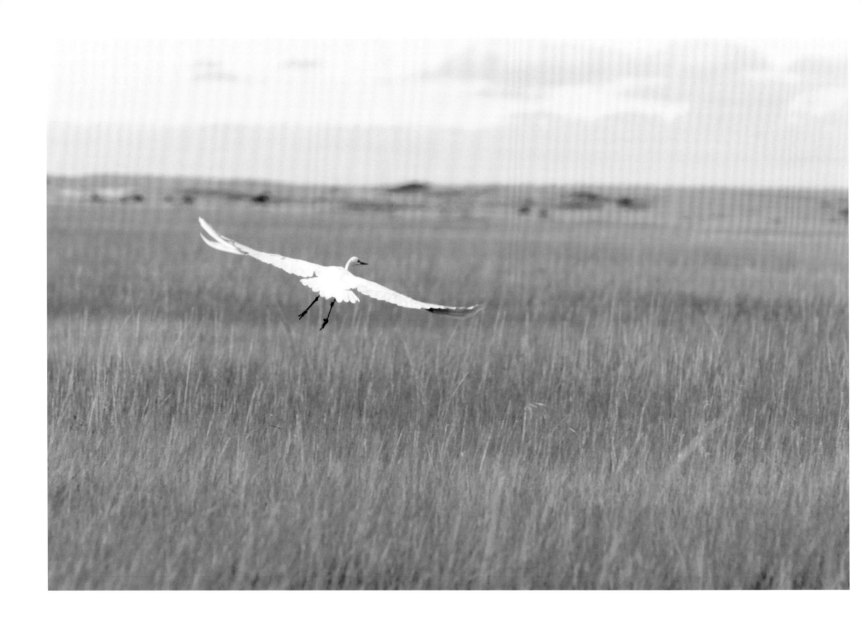

120 Great Egret, Nauset Marsh, Orleans

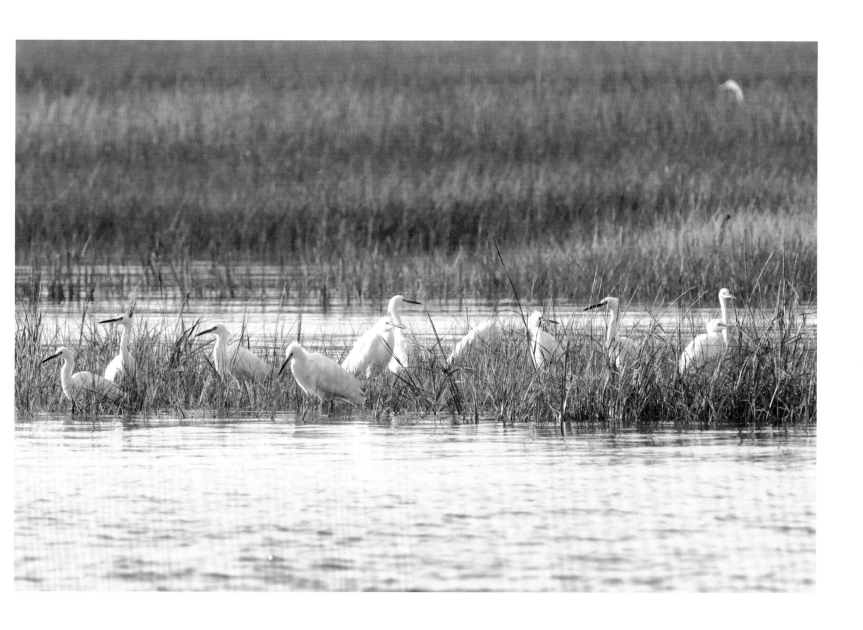

Snowy Egrets, Sampson Island, Orleans 121

122 Footprints in the Dunes, Provincetown

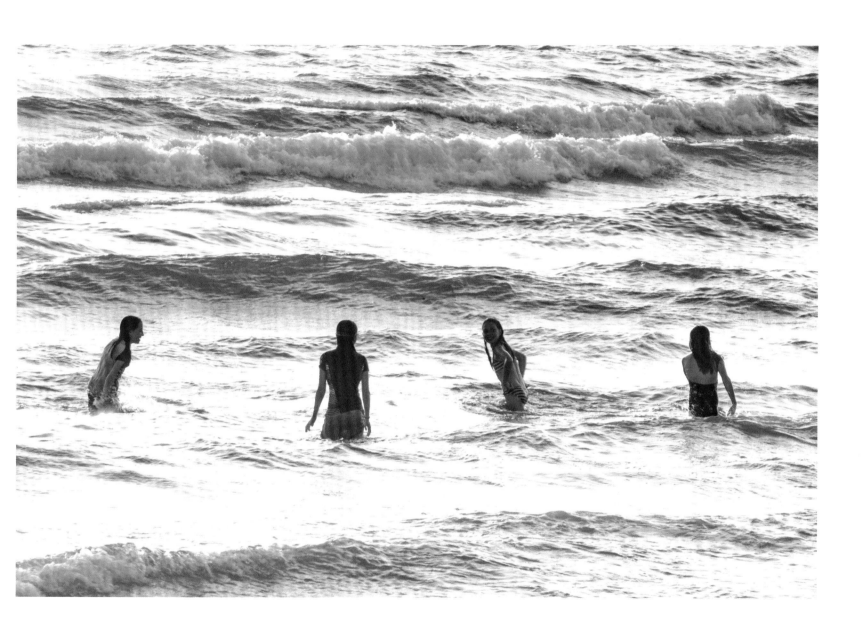

Four Girls Swimming, Old Silver Beach, Falmouth 123

124 Hit!, Eldredge Park, Orleans

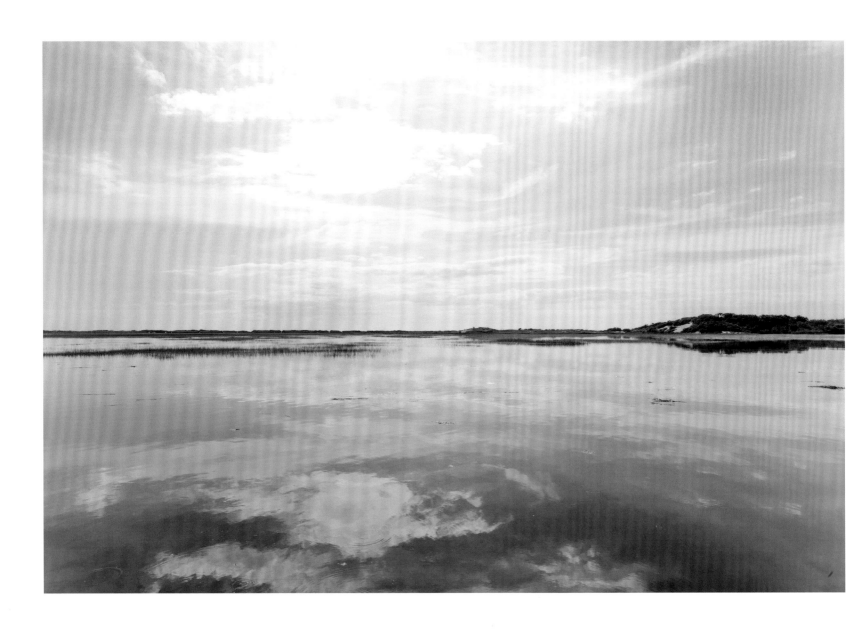

126 Mirrored Sky, Provincetown

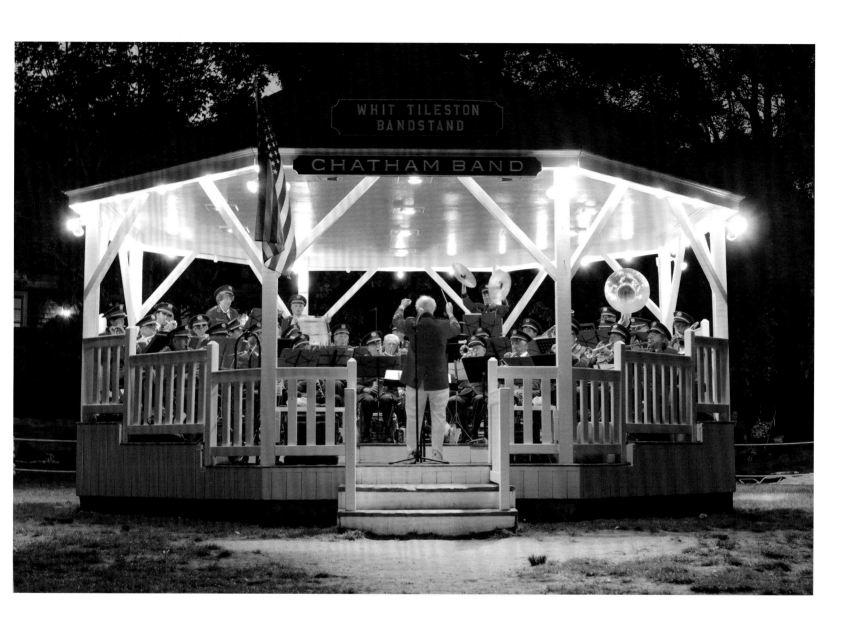

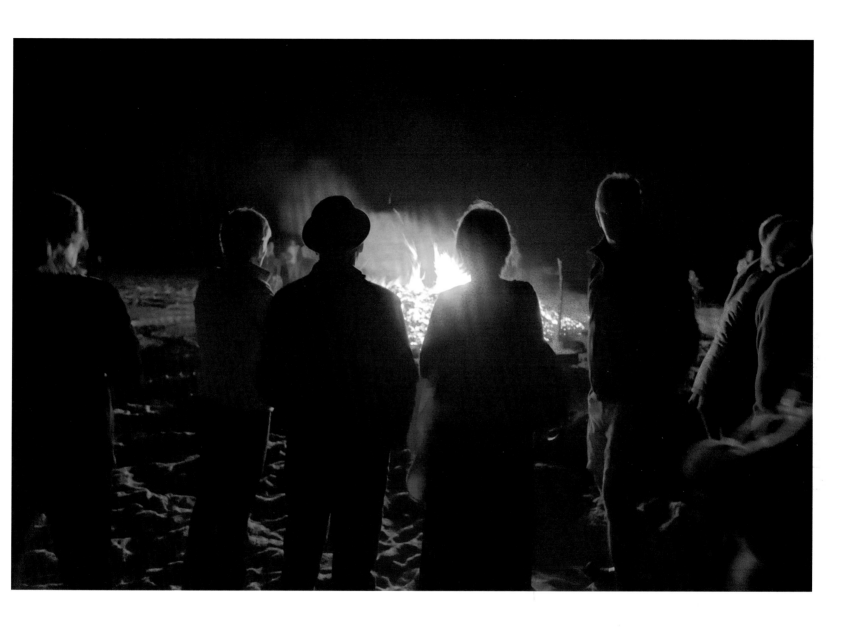

132 Oil Lantern and Reflection, C-Scape

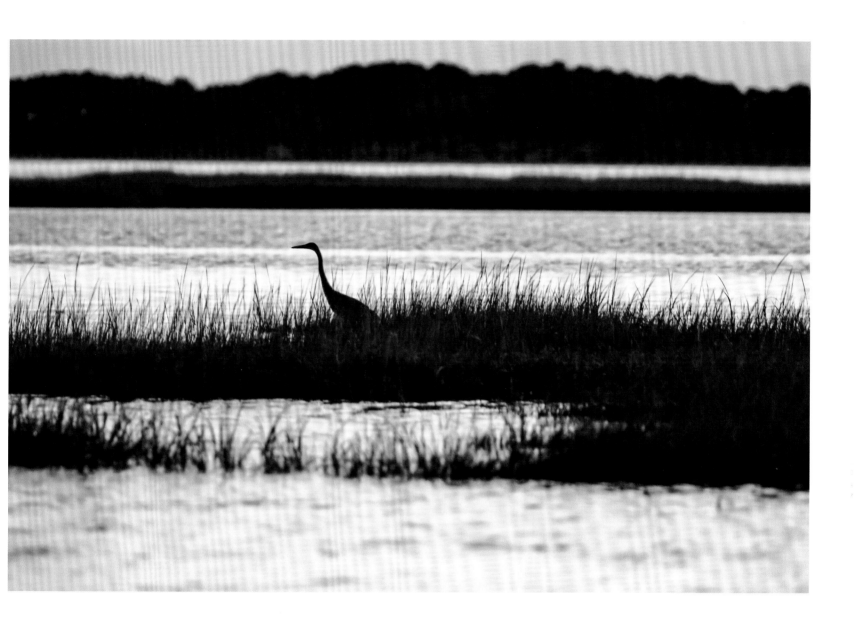

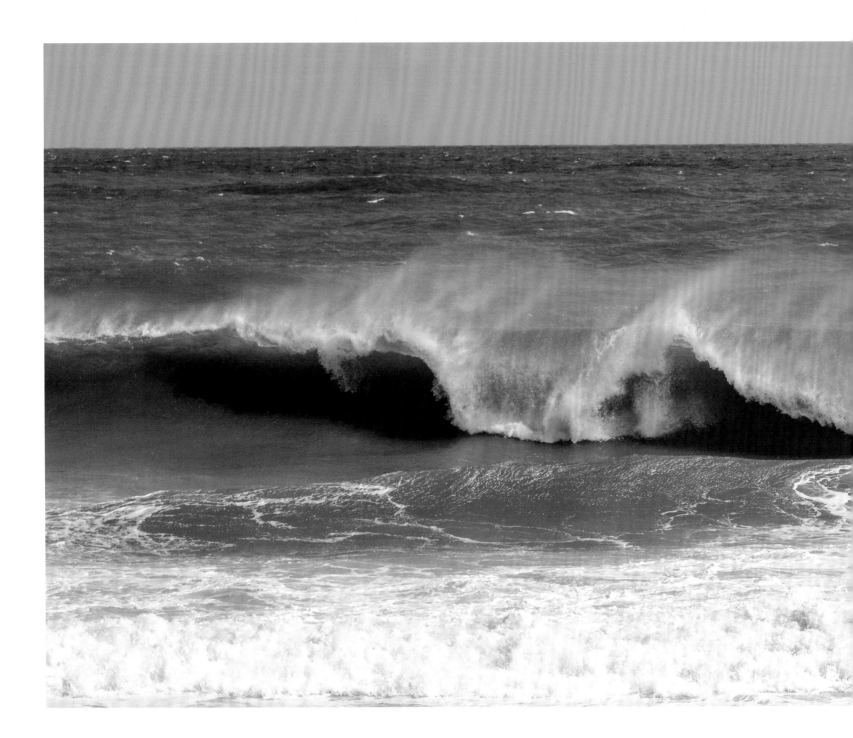

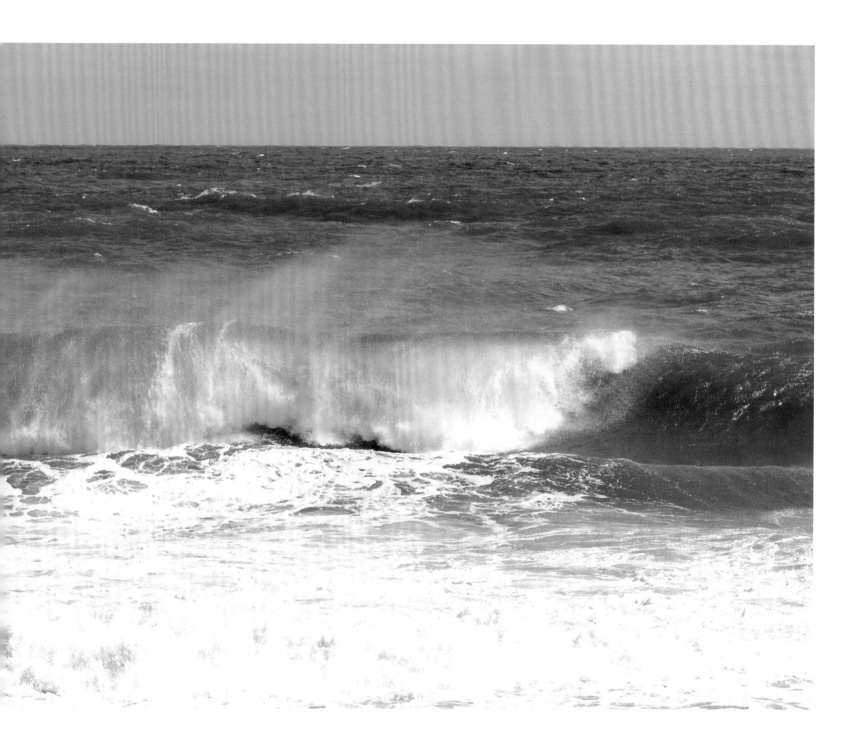

Breaking Wave, White Crest Beach, Wellfleet 135

Fortnight in the Dunes

Harboring the recurrent feeling, like the brooding Wordsworth, that "The world is too much with us," I eagerly seized the opportunity to take up residence for a time in a remote and primitive shack in the dunes of Provincetown. I imagined myself like Alphonse Daudet, who described in the delightful *Lettres de mon moulin* of 1869 his experience of being installed in a romantic abandoned windmill in Provence: "It is so perfect here in my mill! The corner I have been looking for, a small, warm, sweet-scented corner, a thousand leagues from newspapers, cabs, city fog! And so many lovely things around me here!" That is how I hoped to feel there, transported like Daudet to just *"le coin que je cherchais,"* a small place of beauty, calm, and simplicity.

I was also inspired by W. B. Yeats, himself recalling Henry David Thoreau's *Walden* (note the reference to bean rows), first read to him by his father, as he described in "The Lake Isle of Innisfree" an imagined pastoral life on an uninhabited island in Lough Gill in western Ireland:

> I will arise and go now, and go to Innisfree,
> And a small cabin build there, of clay and wattles made;
> Nine bean rows will I have there, a hive for the honey bee,
> And live alone in the bee-loud glade.
>
> And I shall have some peace there, for peace comes dropping slow,
> Dropping from the veils of the morning to where the cricket sings;
> There midnight's all a glimmer, and noon a purple glow,
> And evening full of the linnet's wings.

I will arise and go now, for always night and day
I hear lake water lapping with low sounds by the shore;
While I stand on the roadway, or on the pavements grey,
I hear it in the deep heart's core.

I kept a journal during my stay, thinking it might become part of this book, as indeed it has. I want to convey an eager observer's freshness in the words and images between these covers, accurately representing Cape Cod as a place of lightness and beauty, where one leaves behind at the bridge the seriousness that diminishes our days. Though I wrote from a wild refuge atop a dune at the Cape's tip in my attempt to describe Cape Cod, I could as well have been stationed in any number of similarly alluring and cherished places on the peninsula: a cottage on Sandy Neck, a field camp on Monomoy, or a lighthouse in Bourne. But Boris's shack, a fragile outpost maintained by the Peaked Hill Trust, came my way.

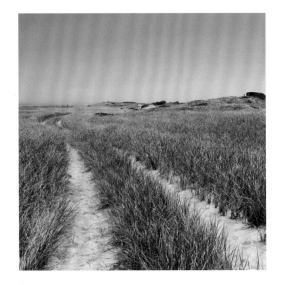

Dune Road to the Shack

JUNE 21. SATURDAY. At around noon my wife Janis and I reached Snail Road, off U.S. Route 6 at the edge of Provincetown, for the trip to the shack. Provincetown marks the eastern end of Route 6, the longest highway in the country. Sal Paradise, Jack Kerouac's protagonist in *On the Road*, considered hitchhiking out west to Nevada on this road, but was informed by a man at a gas station that "there's no traffic passes through Route 6." A sign on the highway here says the road ends in Bishop, California, or perhaps Long Beach (depending on which sign you read). As Thoreau observed, Cape Cod is where a man can stand and "put all America behind him."

Irene, our contact, arrived with an assistant in a dark green Peaked Hill Trust pickup truck, packed us into the back of it with all our food and supplies for two weeks, and then squeezed in two more people with all their supplies. The ride was like a roller coaster, and with nothing to hold onto we bounced about, trying to heed Irene's warnings of particularly rough stretches of trail. Looking out the open tailgate of the truck's covered bed, we saw the dune landscape dreamily receding as we progressed.

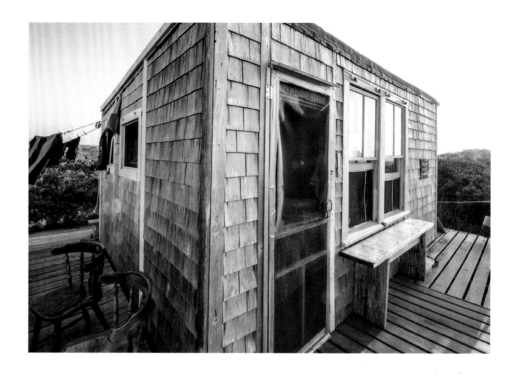

We finally arrived and extricated ourselves from the truck, then carried our goods into the shack. Irene gave careful instructions concerning housekeeping matters such as priming the bright red water pump down the hill from the shack, and using the large heavy pot that balances precariously on the small propane burner for making popcorn to add to the composting toilet in the outhouse. I have never heard of such a process, despite having encountered many outhouses. But this seems to be the Peaked Hill system. Irene suggested we set aside some popcorn to eat when it is time to pop more. After thoroughly instructing us on oil lamps, the propane refrigerator, dune paths, and bedding, and giving ample warnings concerning mosquitos, ticks, and poison ivy, Irene left us to our solitude.

The shack is named after the Russian surrealist artist Boris Margo, who emigrated to the United States in 1930, settling in New York City. Around 1940 he and his wife Jan Gelb built the shack and began spending summers here. The shack

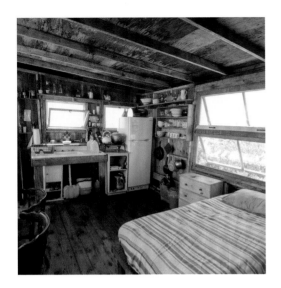

Interior of Boris's

consists of one room and sits on the highest point of the dune, with the wide Atlantic — what naturalist Henry Beston calls "the immense and empty plain of ocean" — in full and stately view just beyond the waving silver-green dune grasses and banks of rugosa roses. When cognoscenti hear that you are going to Boris's for two weeks, the look of envy is unmistakable.

A rough inventory revealed more than enough pots and pans and other kitchen supplies for our simple dining plans, a table, two wooden platform beds, a few books and field guides, a Scrabble set (the pieces in a baggie with a reassuring and recently dated note: "We're all here!"), a few decks of cards, a tool kit and first aid kit, a big metal trunk filled with miscellaneous supplies and blankets, three chairs, a small dresser, three kerosene lamps, and two small mirrors. A narrow deck with a bench and a couple of chairs wraps around the structure. In the back there is a clothesline and a solar shower. No electricity, no running water, and no wood stove. Though small, it promises to be large enough. As Thoreau might ask, for exactly what do we need all the space of our large houses? It is different out here, in this willing exile from the complexity and materialism of modern life. Here is William Wordsworth's dark sonnet, which I mentioned at the outset:

> The world is too much with us; late and soon,
> Getting and spending, we lay waste our powers; —
> Little we see in Nature that is ours;
> We have given our hearts away, a sordid boon!
> This Sea that bares her bosom to the moon;
> The winds that will be howling at all hours,
> And are up-gathered now like sleeping flowers;
> For this, for everything, we are out of tune;
> It moves us not. Great God! I'd rather be
> A Pagan suckled in a creed outworn;
> So might I, standing on this pleasant lea,
> Have glimpses that would make me less forlorn;
> Have sight of Proteus rising from the sea;
> Or hear old Triton blow his wreathèd horn.

The Table

The appeal of Cape Cod is the chance to leave the city in order to find restorative simplification, to be in closer contact with nature, to repair our strained relationship with essential things, to restore "our powers" which have been laid waste, and to retrieve "our hearts." Wordsworth's poem was written as the Industrial Revolution was in full swing with little to check its worst ravages, but even today in our presumably more enlightened world we know exactly what he is talking about. In this shack I sense the regenerative and invigorating idea of Cape Cod in a pure and strong distillation, the exquisite charm of the Cape unadulterated: water, sand, sea breezes, moisture-infused light. This fair place perched on a high sandy bed is dreamlike in its authentic, unforced perfection. It is the embodiment of Cape Cod both as a place and as a state of mind, where one can find harmony with nature while creating some distance from daily routines and responsibilities.

We walked over the dune to the beach and took our first swim in the bracing cold of the Atlantic Ocean. I spent the rest of the day taking my first pictures in the bright sun. By late afternoon, the uninterrupted dome of clear sky clouded slightly, and by evening turned into showy Maxfield Parrish colors. Then came the blackness of the almost-new moon, the sky vibrant with stars and their constellations. The Big Dipper looked grander than ever, its size enhanced by its brilliance, and nearby was the funny misshapen W of vain Cassiopeia. Our Milky Way Galaxy spread above us in a huge arc, a great spiral of billions of stars, unimaginable in vastness but itself such a small part of the universe. Highland Light from Truro reassuringly flashed in the distance, as it has since 1798. We enjoyed a glass of wine on the deck, listening to the unseen breaking waves below. The sounds of crickets are everywhere, this long-awaited first night of summer.

JUNE 22. SUNDAY. Five active birdhouses, occupied by an extended family of Tree Swallows, surround the shack. They swirl around constantly, but most energetically in the morning and late afternoon when insects are in greater supply. The baby birds stick their heads out waiting for a delivery of food, opening their mouths to reveal a bright orange orifice to offer a conspicuous target for their parents. The adults seem infinitely patient and tireless, traits our own species would be

foolish to claim. The birds are entertaining company here, especially as we adjust to this ascetic isolation.

Looking beyond the dune bank to the ocean, the infamous Peaked Hill Bars — the ruin of many ships and men — are clearly visible offshore at low tide, a tan paleness below the waves. They look innocent, these gentle sand formations, yet at one time this was among the world's most perilous maritime passages. Countless ships foundered here when safer waters were only a bit farther offshore, apparently blown off course in storms or lost in conditions of poor visibility. The Cape Cod Canal was built to reduce such loss of life and treasure, and it mostly succeeded in that. Those who still ply these routes have the benefits of modern navigational technology and far better meteorological science. Looking at this gentle seascape, I attempt to imagine the scenes of ships being wrecked here with frequency and violence, and the valiant and dangerous rescue efforts that were launched from the Life-Saving Service station (now gone) that was built on this dune.

Here on Cape Cod I recall the precept of Heraclitus of Ephesus, the pre-Socratic Greek philosopher who lived two-and-a-half millennia ago, that the only constant is change. On this sandy peninsula far from his rocky and durable Ionian home on the Mediterranean, this observation was and continues to be more accurate than he could possibly have imagined. The geography of the Cape is very different today than it was when he lived. The entire hook of the Cape, which is Provincetown and part of Truro, barely even existed in his day, having been formed by accretions of sand over time. In geologic terms, the Cape is laughably insubstantial compared to most settled communities.

At Nauset Beach in Orleans, the strong storms of last winter altered the shore substantially. The walkway, which was secure the previous summer, lay in tatters by spring, ending abruptly in a newly formed ragged cliff. I am inspired by the outer beach at all times of the year, when witnessing the power of a nor'easter, feeling the wind and blowing sand, marveling at an immense tidal surge, or, midwinter, seeing sparkling snow against dark waves in the high-contrast light. Compare these harsher scenes to a warm summer night, moonless and star-filled. Maybe a bonfire is burning on the beach in the distance, the sound of revelers

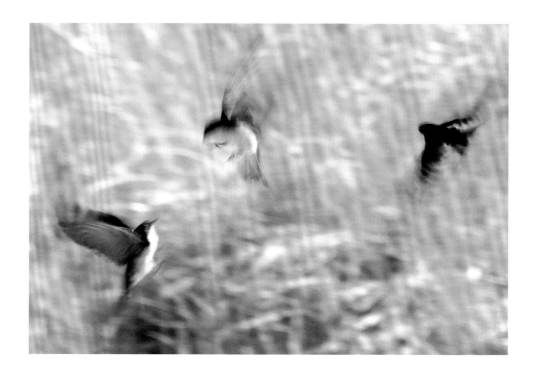

mixing with that of the surf. The beach is never the same twice, not even during one visit. The great barrier beach of Cape Cod is a living organism.

Now I am sorry to finish today's journal entry with the somber news that a young man drowned this afternoon just offshore on these ocean bars. Park Service rescue vehicles' jarring sirens broke the midday quiet. When I went down to the beach, the man's distraught friends were gathered in disbelieving grief. How comfortably we accept the idea of our very existence, forgetting that it is a slight and almost illusory thing that can vanish in a moment on a cloudless June day.

JUNE 23. MONDAY. Today dawned crystal clear and calm. Taking an early walk, I approached a huge flock of gulls, easily in the hundreds, grouped on the shore.

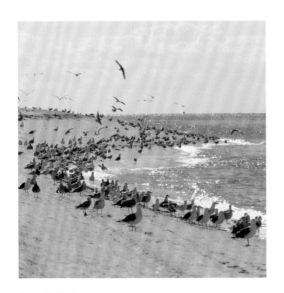

Seagull Colony

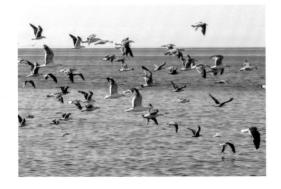

The Birds in Flight

Whenever I came within a certain distance, those nearest would stir and fly off in a block, usually reestablishing themselves at the far end of the flock. While I walked along the shore, the entire group "rolled over" several times. Beston described this phenomenon in *The Outermost House*, his diary of a year in the "Fo'c'sle," his little shack in Eastham where he spent twelve months from 1926 to 1927: "No aspect of nature on this beach is more mysterious to me than the flights of these shorebird constellations. The constellation forms . . . in an instant of time, and in that same instant develops its own will. Birds which have been feeding yards away from each other, each one individually busy for his individual body's sake, suddenly fuse into this new volition and, flying, rise as one, coast as one . . ."

I walked along a path on the high edge of the dune to examine the next shack to the east, Harry Kemp's. It is properly called Tasha's now, after its current owner. From our vantage point at Boris's I thought it was a ruin, with just a section of shingled roof peeking up from the sand, like an old root cellar. But on closer inspection, and after determining it vacant, I found the shack intact though clearly in need of work. There are a couple of squares of cedar shingles in the sand next to the place, bundled and waiting to be put to use, though from the gray weathering it is obvious that they have lain untouched for some time. The door is braced against the wind by a lovely driftwood log and a weathered plank. The smallest of the dune shacks, Tasha's is not much larger than a child's playhouse.

Harry Kemp, who died in 1960 — "the poet of the dunes" — was a famed shack resident and bohemian whose self-promotion and eccentricities became more pronounced and troublesome over time. He fashioned himself as the François Villon of America, referring to the talented and complex 15th century French "poet-criminal." In 1948 Kemp founded a group called the Provincetown Pilgrims Association to draw attention to the underappreciated fact that the Mayflower landed in Provincetown before going on to Plymouth, disputing what he referred to as "the hoax of the rock." He was by all accounts a large man, so it is interesting to imagine him inside his minute home up here. Kemp was in his later years watched over by Hazel Hawthorne Werner, proprietress of two dune shacks,

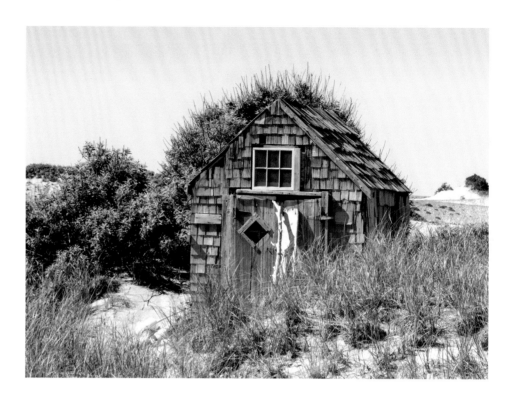

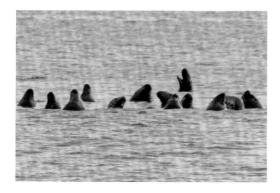

Gray Seals on the Bar

Thalassa and Euphoria, and she eventually built a little house behind her own in Provincetown where Kemp could be kept safe and in view. You pass Harry Kemp Way, a street just before Bradford Street in Provincetown, on your left as you come into town from Route 6 on Conwell Street.

The weather this afternoon turned cool and breezy, so we dove into our duffle bags seeking warmer clothes. We went down for a swim anyway, taking the rose-filled path that winds to the sea. Seals were swimming close by, so I knew to watch for the great white sharks who comb these waters. Sharks greatly prefer seals to humans for nourishment. However, recently a shark bit a swimmer off Truro; he survived quite intact and now has a fine story to tell with a scar to back it up. With no shark encounter to mar the afternoon (or our bodies), we enjoyed the water and the company of seals. I stayed up late, by lamplight rereading Thoreau's somewhat unusual and occasionally comical reports of his Cape Cod

excursions. I had forgotten the part where he and his companion are quite seriously suspected of having broken into the safe at the Provincetown Bank!

JUNE 24. TUESDAY. As I told people of my intention to withdraw to a primitive shack in the dunes for two weeks, I found I could be certain of one of two replies. The first was, "That's the most incredible opportunity; I'm so envious!" The other response was, basically, "Are you crazy?" I admit that the skeptics occasionally caused me to waiver slightly in my enthusiasm, but having been here for a few days now, I suggest that many might adjust their opinion if given the chance to experience the delights of this little abode.

For example, this morning I awoke to the astonishing sight and sound of a very large herd of gray seals, probably more than one hundred, gathered on the sandbar and singing in a remarkable and otherworldly chorus. The bar was underwater, as always, but the tide was low enough for the creatures to relax on it. Some of their number seemed to be standing, a phenomenon I had read about but never witnessed. The choir reminded me of the sonorous tones of throat-singing Tibetan Buddhist monks, mysterious and eerie.

The full midday sun releases an intense scent from the rugosa roses that cradle the shack. The originally Asian beach roses are a serendipitous non-native species. It is hard to imagine these hills without their rich foliage of varying depths of green, the intense pink and occasionally white flowers, and the plump, deep orange-red rose hips. The sweet perfume blends consummately with the salty sea air. Thoreau's description of much of the Cape as desert would have been moderated had the roses arrived — by means that are not fully clear — before his visits. He observed mostly low-growing poverty grass, a humble species still abundant here, capable of thriving with little sustenance. It had naturalized after arriving with a shipment of pine trees from Scotland, bringing a bit of welcome color to the sands in the form of tiny pink or yellow blooms, reminiscent of miniscule lanterns. Our little peninsula is much more inviting today, with its roses and masses of undulating dune grass. (The tedious grass planting was described by Thoreau, who was certain that the government was being swindled in the mission by locals taking advantage of the state's largess and presumed ineptness.) If

Rugosa Blooms

Thoreau could see the dunes today, with their roses in profusion and the thriving fields of grass, he would be impressed.

Provincetown is a perfect place to reflect on Cape Cod's earliest role in the American experiment. The Mayflower crew's first sighting of land in the western hemisphere, in November of 1620, was the coast of Cape Cod. Storms kept them from adjusting course to the south, to their intended destination at the mouth of the Hudson River, in what was then the northern reach of the territory of Virginia. While anchored in the shelter of today's Provincetown Harbor, they repaired their damaged shallop, the boat that served as a landing craft, and began a small series of "discoveries," as they called them, on Cape Cod. Bartholomew Gosnold arrived here earlier, anchoring in the same harbor in 1602, before exploring the peninsula. He is responsible for the name Cape Cod, having noted the great abundance of these fish in the area. Samuel de Champlain, a mariner and man of many other skills, arrived on Cape Cod in 1605 on behalf of King Henry IV of France, anchoring in Chatham's Stage Harbor in the fall of 1606. He did his own exploring and mapping of the area, choosing to call it Cape Malabar in recognition of the troublesome shallow waters. There was also an unfortunate encounter — the details of which remain unclear — between his men and the Monomoyick natives, resulting in fatalities on both sides. After he and his all male crew abandoned Cape Cod, effectively ending French designs on this part of the New World, Champlain went on to great fame as the founder of New France to the north.

While the Pilgrims' best known enterprise was the Plymouth Colony, it was during their brief time at harbor in Provincetown that the Mayflower Compact, the seminal and foundational document of their project, was written and approved. During the interlude in Provincetown, tension developed between the Separatists and those on the ship whose goals were more entrepreneurial. The drafters seized the opportunity to create a just dispensation for the group. With the plan to settle as planned and authorized in Virginia now relinquished, a window opened for William Bradford and the other leaders to describe to their own satisfaction the

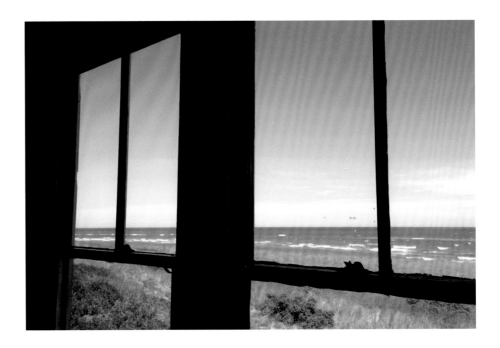

idealistic goals of their rapidly evolving experiment. Bradford's rationale was that "they would use their own liberty; for none had power to command them, the patent they had being for Virginia, and not for New England, which belonged to another Government, with which the Virginia Company had nothing to do."

Thus the accidental landfall on Cape Cod was ultimately beneficial, for it led to the articulation of a concept that would henceforward guide their "civil body politick" to an acceptance of the proposition that a government's authority derives from the consent of the governed. That salutary proposition has endured through various iterations, becoming the keystone of the United States' constitutional democracy. The Mayflower Compact, at just 196 words, is wonderfully concise. The two key documents it presages retain much, though a diminishing amount, of this restraint: the Declaration of Independence is 1,337 words and the United States Constitution is 4,400 words. The recently drafted constitution for the European Union is near 70,000 words.

Provincetown commemorates the Pilgrims' arrival with an unusual 252 foot-high granite monument (offering a commanding view from the top), modeled on

Italy's Torre del Mangia, which overlooks the Piazza del Campo in Siena. Whatever debt we owe the Pilgrims and however much we honor and memorialize their courage and vision, they of course were visitors to a land that already had a long history of human habitation. Archeologists have found Paleoindian projectile points at multiple sites on Cape Cod, indicating a human presence dating back 10,000 years, and the human presence here by 5,000 years ago was extensive. The arrival of Europeans on Cape Cod would lead soon to the destruction, intentional or not, of almost all the settled native populations of coastal New England. We compartmentalize this sweeping and tragic part of our history, since it is problematic to integrate with our received history. At John Kennedy's presidential inauguration in 1961, the beloved New England poet Robert Frost, unable in the winter glare to read the poem titled "Dedication" that he had written for the occasion, instead "stole the hearts of the inaugural crowd," as the *Washington Post* noted, by reciting his poem of 1941, "The Gift Outright," from memory:

> The land was ours before we were the land's.
> She was our land more than a hundred years
> Before we were her people. She was ours
> In Massachusetts, in Virginia,
> But we were England's, still colonials,
> Possessing what we still were unpossessed by,
> Possessed by what we now no more possessed.
> Something we were withholding made us weak
> Until we found out that it was ourselves
> We were withholding from our land of living,
> And forthwith found salvation in surrender.
> Such as we were we gave ourselves outright
> (The deed of gift was many deeds of war)
> To the land vaguely realizing westward,
> But still unstoried, artless, unenhanced,
> Such as she was, such as she would become.

It is stirring and optimistic verse, and superior to his didactic purpose-composed "Dedication" which is four times as long and largely forgotten. But most non-native people hearing or reading "The Gift Outright" should feel some contrition over this soaring narrative. Here is Derek Walcott on this, the force of his comments enhanced by his multi-racial ancestry:

> On that gusting day of the inauguration of the young emperor, the sublime Augustan moment of a country that was not just a republic but also an empire, no more a homespun vision of pioneer values but a world power, no figure was more suited to the ceremony than Robert Frost. He had composed a poem for the occasion, but he could not read it in the glare and the wind, so instead he recited one that many had heard and perhaps learned by heart. This was the calm reassurance of American destiny . . . No slavery, no colonization of Native Americans, a process of dispossession and then possession, but nothing about the dispossession of others that this destiny demanded. The choice of poem was not visionary so much as defensive. A Navajo hymn might have been more appropriate: the "ours" and the "we" of Frost were not as ample and multihued as Whitman's tapestry, but something as tight and regional as a Grandma Moses painting, a Currier and Ives print, strictly New England in black and white.

Living in a two hundred square-foot shed and looking out on the waters and dunes where the whole story began to unfold, and seeing around me no more indication of civilization than the audacious Mayflower voyagers saw at first landfall in this hemisphere, provides ample opportunity for reflection.

JUNE 25. WEDNESDAY. All last night the wind was up, sometimes in sudden gusts, while our shack, like a boat moored in a sea of sand, shook but held firm with each new blast. This morning continues to be windy and noticeably more humid, portending a possible weather change. Until now conditions have been mostly near-perfect: sunny, low humidity, gentle breezes.

The world is simple here: sky, water, dune. The colors and light and patterns

Back Window View

always change, but the template is fixed. This simple visual structure embodies the French idea of the *cadre,* the frame we do not wander beyond, but within which we can safely and fully enjoy our freedom. The limitations of the frame emancipate rather than restrict. Thoreau's exhilarating freedom was found within the confines of his cabin and grounds at Walden Pond. Here on our comforting Cape Cod, we can simplify and revel in nature, disconnecting from our complex and stressful lives. With an endless combination of pastimes and creative endeavors, everyone finds their own version of the place. Vacationing here — going "down the Cape" — means something different to everyone: a cottage with a path to a pond, a house on the ocean shared with friends, or perhaps a quiet inland piney retreat just a short ride to the beach — for of course everything here is at most a short ride to water of some sort, on this pond-strewn, ocean-surrounded arm of land.

Certainly the seashore remains paramount here, the *sine qua non* of a Cape idyll, and explaining that allure is difficult, if not impossible. I found a copy of Walt Whitman's *Specimen Days & Collect* here in Boris's shack, and copy here his "Seashore Fancies" passage:

Even as a boy, I had the fancy, the wish, to write a piece, perhaps a poem, about the seashore — that suggesting, dividing line, contact, junction, the solid marrying the liquid — that curious, lurking something (as doubtless every objective form finally becomes to the subjective spirit) which means far more than its mere first sight, grand as that is — blending the real and ideal, and each made portion of the other. Hours, days, in my Long Island youth and early manhood, I haunted the shores of Rockaway or Coney Island, or away east to the Hamptons or Montauk. Once, at the latter place (by the old lighthouse, nothing but sea-tossings in sight in every direction as far as the eye could reach), I remember well, I felt that I must one day write a book expressing this liquid, mystic theme. Afterward, I recollect, how it came to me that instead of any special lyrical or epical or literary attempt, the seashore should be an invisible *influence,* a pervading gauge and tally for me, in my composition. (Let me give a hint here to young writers. I am not sure but

I have unwittingly followed out the same rule with other powers besides sea and shores — avoiding them, in the way of any dead set at poetizing them, as too big for formal handling — quite satisfied if I could indirectly show that we have met and fused, even if only once, but enough — that we have really absorbed each other and understand each other.)

There is a dream, a picture, that for years at intervals (sometimes quite long ones, but surely again, in time) has come noiselessly up before me, and I really believe, fiction as it is, has entered largely into my practical life — certainly into my writings, and shaped and colored them. It is nothing more or less than a stretch of interminable white-brown sand, hard and smooth and broad, with the ocean perpetually, grandly, rolling in upon it, with slow-measured sweep, with rustle and hiss and foam, and many a thump as of low bass drums. This scene, this picture, I say, has risen before me at times for years. Sometimes I wake at night and can hear and see it plainly.

JUNE 26. THURSDAY. There was terrific rain last night, sounding almost like hail, and finally ending this morning with a classic Cape Cod fog blanketing dunes and ocean. Quite a few significant leaks developed during the night, requiring the use of many pots and buckets, creating a symphony of drips and plops of varying timbres and rates. Irene had shown us on arrival several circles drawn in black marker on the plywood ceiling, which were meant to forewarn us of the location of possible leaks. They bore no relation to where our leaks occurred.

The rain increased the mosquito population, to our dismay but much to the benefit of the sparrow parents. We quickly attended to any necessary screen repairs. Luckily ample duct tape was on hand. I have read that tourism on the Cape was immeasurably aided in the mid-twentieth century by mosquito control schemes. They were wrong-headed environmentally, applying pesticides, draining wetlands, etc. The familiar story handed down is that the efforts succeeded in making the place more inviting, though likely other factors, including expanded development and natural changes, were at work. One still sees the anachronistic dark green Cape Cod Mosquito Control trucks driving around.

The work of actually preserving Cape Cod's unique and fragile environment —

as opposed to killing mosquitos — began at least as far back as Thoreau's time, although we can assume that the native populations likely approached the environment with great care long before that, as an appreciation of the natural world was integral to their survival. All of the very substantial old-growth forest of Cape Cod was ultimately consumed for fuel and lumber, though there is some debate about the degree of existing forest on the Cape when Europeans first arrived. Thoreau makes the shrewd observation that the religious Pilgrims described the Provincetown area in glowing terms by noting its lush vegetation, supporting their hopes for a welcoming world sanctuary, while the non-religious and more pragmatic arrivals were more struck by the harsh dune habitat.

Thoreau accurately predicted that the Cape would become a popular destination for visitors eventually, though it must have required ample imagination. And while he thought that inevitably "this coast will be a place of resort for those New-Englanders who really wish to visit the seaside," he went on to note

Postcard, Postmarked 1909

that it was currently "wholly unknown to the fashionable world, and probably it will never be agreeable to them." Over time of course Cape Cod indeed became "agreeable" to tourists, fashionable and otherwise, though it experienced periods of growth and contraction. Increased access through rail and automobile travel was the key ingredient, but the Cape Cod Canal, by turning the peninsula into an island, technically, slowed things down. Railroad and auto bridges in various incarnations reconnected things over time. The three current bridges were built using funds from the National Industrial Recovery Act as part of federal depression-era stimulus. They are lovely structures, the art deco Sagamore and Bourne (though often cursed by drivers on summer weekends!), and the Cape Cod Canal Railroad Bridge (also called the Buzzards Bay Railroad Bridge), which when built was the world's longest vertical lift span. The contribution to the latter's design by McKim, Mead & White can be seen in its Beaux-Arts details and in the arch's graceful camber.

Despite the now fashionable connotations (Thoreau notwithstanding), much of Cape Cod remained rustic well into the 20th century. Our late friend and family babysitter Dorothy and her sister used to tell tales of getting into various kinds of Tom Sawyer-like mischief, such as commandeering — *maybe* with someone's tacit permission? — the hand-driven pump trolley used for inspecting the tracks on the rail line that ran through town. Dot also told the darkly comical story of how their family's house in Orleans burned to the ground, firemen arriving late to the scene because they were all out clamming, and even worse, were using their protective fire outfits as waders. She described lengthy winter automobile journeys from Orleans to Provincetown, the children tucked into their seats with crumpled newspapers in an effort to stay warm. Along the way they would see bunches of asparagus by the roadside, grown in the sandy soil, left to be collected for sale in Boston. If you are observant, in early summer you will notice that many of the Cape's random weeds are actually untended asparagus plants grown out to ferns.

Cape Cod still has the patina of those older times, often noticed in small and subtle ways: seafood shacks with casually painted signs, town landings hidden at the end of dirt roads, families enjoying the beach in unhurried Norman Rockwell

MAIN STREET, ORLEANS, CAPE COD, MASS.

49608

leisure. We still enjoy Patti Page's 1957 hit "Old Cape Cod," and embrace its treacly message because it remains surprisingly accurate. The song's enticing imagery of a fabled leisure destination led to a sustained spike in tourism, as the images of quaint villages and moonlit nights on Cape Cod Bay offered an antidote to sterile postwar suburbanization. When John Kennedy became president a few years later, and people saw photos of the dashing young idealistic president and his beautiful wife and extended family at their compound in Hyannis Port, it was a felicitous moment that added permanent luster to this quiet sandy arm of land.

JUNE 27. FRIDAY. Bright, dry weather returned this morning, though the wind is still up after a blustery night, and the ocean is full of whitecaps. We needed our down sleeping bags last night. These bags have served us well for decades, whether on Mount Rainier in Washington or in the Kali Gandaki Gorge in Nepal. That parts of this "wild, rank place," by Thoreau's reckoning, could remain nearly as exotic as those distant venues would not be possible without the Cape Cod

National Seashore. The park protects precisely those areas that caught Thoreau's attention on the maps he studied in Concord — specifically the long unbroken beach, which he aptly named the "Great Beach." In one sweeping breathtaking action, and after overcoming imposing opposition, a truly vast area of the peninsula from Chatham to Provincetown was permanently conserved. I question whether our government could manage a similarly daunting and controversial task today.

While writing *A Sand County Almanac*, Aldo Leopold also lived in a shack — his in Wisconsin. It was published in 1949, almost a century after *Walden*, and not long after he died fighting a forest fire. Leopold develops his seminal concept of a "land ethic" by carefully analyzing the limitations of modern ways of relating to the land and the environment, and by proposing an alternative: "It is inconceivable to me that an ethical relation to the land can exist without love, respect, and admiration . . . Quit thinking about decent land-use as solely an economic problem. Examine each question in terms of what is ethically and esthetically right, as well as what is economically expedient. A thing is right when it tends to preserve the integrity, stability, and beauty of the biotic community. It is wrong when it tends otherwise." Cape Cod, admired and enjoyed by so many (yes, probably too many), has become a laboratory for preservationists and conservationists, where multiple strategies and platforms — governmental legislation, regulation, land acquisition, conservation trusts, and educational and scientific organizations — work together to advance a set of shared values.

Leopold says that the adoption of a land ethic must ultimately be a product of social evolution and increased awareness: "Our ability to perceive quality in nature begins, as in art, with the pretty. It expands through successive stages of the beautiful to values as yet uncaptured by nature." I see the multi-faceted land protection effort on Cape Cod as an exemplar of his ecological ideals, as an advancement of the ethical frontier.

At sunset we saw the elusive green flash, the mirage-like artifact of the last moment of sundown. Soon after on the opposite horizon the pink Belt of Venus

was lovely, above the band of gray Earth-shadow. Tonight is the new moon, and I plan to be out later for astronomical explorations under the clear sky.

JUNE 28. SATURDAY. I woke in the deep of night to examine the heavens, the sky so dark and clear that I could see the Andromeda Galaxy unaided. A trillion stars, more than twice as many as in our own Milky Way, but just a barely visible smudge in the sky to us! After a while I got chilled and came back in to be lulled to sleep by the sound of waves and the soft foghorn from the harbor in Provincetown. I awoke a little later to a wild howling chorus of coyotes in the distance, an uncanny commotion of exaggerated noise. It is said that people sleep exceptionally deeply on Cape Cod. Perhaps it is the dark, or the fresh air, or the (mostly) calming natural sounds. It is difficult to find a decent night sky in most places now, and that is a terrible loss. A clear night sky full of shining stars and planets orients a person in the cosmos.

Our swallows have become such fine company for us here, dear little busy friends so proficiently doing exactly what nature expects of them without any

Nightfall

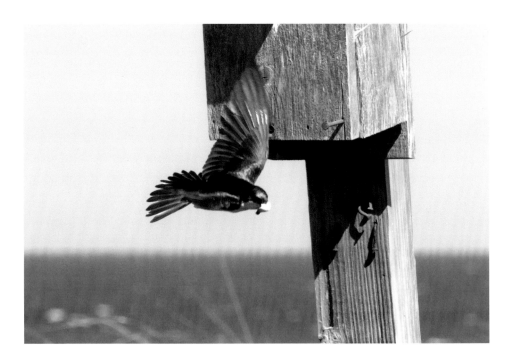

complaint. Just as described in a field guide here, for example, periodically an adult plunges into the birdhouse, and after a flutter of activity flies out with a little white fecal sac (or "birdie diaper," as it has been called) which it then drops in the grass some distance away. We had observed this a few times before realizing what was going on. Janis said it reminded her of the earthworm dissection in high school biology, where to her delight everything was just where the textbook said it should be! There is much reliability in nature, essential and purposeful repetition. I occasionally envy the Tree Swallow and covet its modest mission.

Though we declare that we are free to fashion our lives beyond the dictates of nature, society forces us into over-determinative paths. How liberating to be like Thoreau: hermit, writer, moralist, teacher, surveyor, pencil-maker, gardener, gadfly. We limit ourselves much more than we realize, and society rewards us for that narrowing. A Cape Cod interlude allows us to expand beyond the strictures we live within. Perhaps that is why courses in the arts are so popular among summer visitors, providing an opportunity to try being someone else for a while.

Thus one may write a poem or story while on vacation, perhaps about the Cape, perhaps to share with others or else to keep secret to be read to oneself by a fire at home in coldest winter. Such a souvenir might be akin to Edna St. Vincent Millay's "Memory of Cape Cod," the soft elegy loved by Jacqueline Kennedy Onassis:

> The wind in the ash-tree sounds like surf on the shore at Truro.
> I will shut my eyes . . . hush, be still with your silly bleating, sheep on
> Shillingstone Hill . . .
>
> *They said: Come along! They said: Leave your pebbles on the sand and come along,*
> *it's long after sunset!*
> *The mosquitoes will be thick in the pine-woods along by Long Nook, the wind's*
> *died down!*
> *They said: Leave your pebbles on the sand, and your shells, too, and come along,*
> *we'll find you another beach like the beach at Truro.*
>
> Let me listen to wind in the ash . . . it sounds like surf on the shore.

Or, you can set up an easel *en plein air,* returning home with a painting, perchance inspired by Edward Hopper's "Cape Cod Morning," in which the woman in the orange dress with her red hair pulled back gazes out expectantly from the tall bay window — one of those classic bay windows of Cape farmhouses — at the field of high golden grass bordered by trees of variegated greens. (Hopper's wife Jo thought it was just "a woman looking out to see if the weather is good enough to hang out her wash," though I find it much more nuanced.)

Hopper of course was associated with Cape Cod for many years. Gail Levin's book *Hopper's Places* documents many of his subjects and pairs them with more recent photographs. One of my favorite Hoppers is the 1950 "Portrait of Orleans," a wistful masterpiece that depicts the old downtown Main Street block, much of it unchanged today. (It resides in the de Young collection in San Francisco.) Our late friend Jimmy DeLory owned one of the Cape Cod gas stations Hopper is well known for painting. He told us they had a strict rule never to let the renowned

Fog Approaching

artist drive his car into the service bay, as his driving skills were very poorly regarded.

Clouds have drifted in from the northwest, along with a mild cold front. There is still time for a swim before the late-setting sun. Our neighbors in Euphoria shack, who we only saw at a distance, have departed after their one-week stay. We are glad to have another full week in store here, as this first one has flown by.

June 29. Sunday. Today I spent the morning exploring the beach, walking west toward the Coast Guard Station at Race Point, and then doubling back and eastward into Truro, a trek of several hours. I jumped into the ocean from time to time to stay cool under the strong sun, leaving my camera wrapped in a t-shirt on the beach. Thoreau walked prodigious distances on his excursions, as he called them, with no hint of tiredness and certainly none of boredom — except when he had to walk through towns, which seemed to depress him. He often sought alternative routes, complaining that people always wanted to direct him through the dreaded towns, even when those routes brought him considerably out of his way. Walking along the outer beach and watching the waves in action, Thoreau was fascinated by the permeability of the sand as the waves rolled in: "The sea was still running considerably. It is surprising how rapidly the water soaks into the sand, and is even dried up between undulations." Thoreau was observing constantly, not just covering distance. Then again, this *was* all new to him. A typical Concord man of his era would likely never have encountered a wild ocean beach in his lifetime. I strive to keep alive that surprise and sense of discovery and wonder here on Cape Cod, and the diverse environment of the peninsula provides rich material. Walking may be the best means to that end, and the Cape is indeed a great place for walking.

On the path to the beach I startled two large hognose snakes, and they tumbled clumsily down the small bank by the side of the path in their efforts to escape notice, before reclaiming their "footing" and slithering off into the high grass. While walking the strand, I occasionally passed large heads of striped bass, left

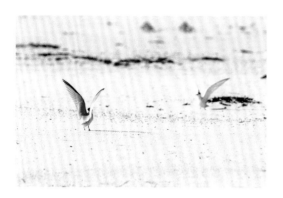
Two Terns

behind by surf casters. I eventually came to the Least Tern and Piping Plover nesting areas, protected from humans in zones demarcated with strings tied to wooden stakes.

As I drew closer, the terns began to dive-bomb me, and it was actually a bit frightening. Now I understand why the rangers wear protective gear when they inspect the areas. The Piping Plovers are lovely sand-colored birds who nest camouflaged in exposed open areas of beach, an adaptation which had evolutionary value but which today puts them at particular risk from motorized beach vehicles. One fluffy young plover, not yet able to fly, thought himself terribly clever by jumping into a small depression in the sand, which only marginally lessened his visibility. Within the broadly protected zone is a wire fence forming a circle about two yards in diameter, and within this exclosure, as it is called, a plover hen sits like royalty on her eggs in an indentation in the sand, protected from predators such as foxes or raccoons, reminding me of the protected rose in Saint-Exupéry's *The Little Prince*.

Later this day we hiked through the dunes to Provincetown to restock a few things and to have a look at the fishing boats decorated for the annual Blessing of the Fleet. We had intermittently discussed whether we should venture into town — how best to avoid the midday heat, what to do there, what to buy, etc. — so often and with such notable lack of conviction (and always leading to no firm conclusion) that we began joking about this being like *Waiting for Godot* set in the Provincetown dunes.

But today we finally took bold action and headed out on the sandy path to town, arriving in time to fall in with the crowds, large even by Ptown standards, that had gathered for the Portuguese Festival. We walked through town and out onto colorful MacMillan Pier, then enjoyed dinner at Napi's, a popular restaurant. We returned home just as darkness fell over the dunes. Oil lanterns lit, we contentedly settled back into Boris's for the night, jumbled images of town fresh in our minds. Going to Provincetown is always an interesting experience, with the mélange of artists and fishermen, the large LGBTQ community, and —

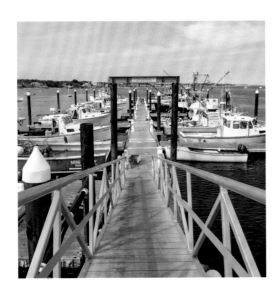

Boats at MacMillan Pier

in summertime — hordes of tourists. I think it is accurate to call it a unique town, and today it was almost too much so for a couple of dune-dwelling recluses.

JUNE 30. MONDAY. "Only that day dawns to which we are awake." The significance of the antepenultimate sentence from *Walden* is palpable here, as the full summer sunlight saturates everything in the cabin so quickly, reminding me to wake up not just physically, but also spiritually, intellectually, even morally. Our first image of Thoreau is as hermit philosopher and observer of nature. Like the eminent humanist Montaigne (*"Que sais-je?"* — "What do I know?" — being his skeptical motto), Thoreau constructs an intimate connection with the reader out of anecdotes and observations. As a key exponent of Transcendentalism, he ventures into far-reaching intellectual territory, the natural world being his muse, and like Leonardo da Vinci considers that world the source of truth. Then in 1849 — *tout à coup* — comes a startling essay called "Resistance to Civil Government" (later referred to as "Civil Disobedience"), which sets forth a moral and political proposition of tremendous importance. Incubated during his stay at Walden, the essay reveals the extent of Thoreau's brilliance.

The value of the principle of non-violent or passive resistance — the central idea of the essay — cannot be overstated. Thoreau refused to pay his poll tax in response to a government that supported slavery, an institution he deeply abhorred, and which was engaging in actions in the Mexican-American War that he considered imperialistic. He spent a night in jail, released after his aunt paid the taxes despite his objection. Thoreau knew that democracy, which he reluctantly accepted as the best form of government, would often fail morally, and thus it was the responsibility of the individual to take non-violent actions to interfere with the continuation of those unacceptable policies.

"Civil Disobedience" provided a road map for the struggles and achievements of Mahatma Gandhi, who translated it into Hindi in 1907 while living in South Africa and advocating for Indian rights. It became a key element of his philosophy of *Satyagraha* (meaning "insistence on truth" or "truth force"), and both directly and via Gandhi's interpretation it formed the basis for Martin Luther King's civil rights strategy of sit-ins, freedom rides, marches, and boycotts. It is not a coin-

cidence that Thoreau's simple life at Walden Pond, at a remove from government and society, helped shape his thinking about justice and personal responsibility. I have observed that a moral dimension is often prevalent in the genre of nature writing, driven by the contrast between an authentic and often threatened natural environment and the wide range of misguided or evil actions of human beings. Many writers' names come to mind, obvious ones being John Muir, Aldo Leopold, Joseph Wood Krutch, Rachel Carson, Gary Snyder, Wallace Stegner, and Bill McKibben.

At this point let me anticipate some concerns that I have steered perilously close to making this a journal too much about Thoreau. I feel that he first created the idea of Cape Cod as a land of wonder and interest, helping establish it as "a place apart," to use Robert Frost's expression. (Thanks to Robert Finch for that association.) Thoreau created an identity of the Cape that exceeds mere location. He helps us see all the "great many intertwinkling facets" — a Nabokovian locution — of the place as friend and fellow discoverer. His writing is so fresh and unaffected that we feel he must be our contemporary. I would give a great sum to be guided around the peninsula with him today — Virgil to my Dante — walking from Sandwich to Provincetown, exploring the long Atlantic shore, sharing his heightened sensibilities and unbounded curiosity.

After Sunset

We gathered some sea lettuce which had been tossed up on the beach in abundance in the recent ocean churn, rinsed it numerous times at the pump to remove the sand, and enjoyed it for lunch tossed with olive oil and, of course, sea salt. Beach peas have not yet progressed to an edible state, but some rose hips are beginning to ripen, which will make a healthy tea. A hot wind has been blowing strong and steadily for most of the day, and while my sanity is not yet in danger as *les Provençals* firmly warn of their famous *mistral*, I have chosen to remain inside for a while.

At sunset we tried to find the green ray again, the ocean horizon pristine and the water calm. It did not materialize, but the sun rewarded us by displaying itself as a magnificent deep orange ball descending in stately manner. We Earthlings

fall so naturally for the illusion that the sun is setting, when it is we who merely spin away from it until we greet our local star again in the east the next morning. After such a hot day, the air cooled down pleasantly. Relaxing in the soft evening breeze, I am a bit concerned about how much of the world I will never see. But then I am reassured with the thought of the artist Joseph Cornell, who lived all his years in a small house on wonderfully named Utopia Parkway in Queens, never traveling beyond the New York City area except for an interlude attending Phillips Academy in Massachusetts.

JULY 1. TUESDAY. The wind shook Boris's from all sides last night, whistling through every crevice. The weather often feels more volatile and uncertain up on this dune. July 1st marks the start of the two full-on Cape Cod summer months, and it is starting according to script, the air being notably warmer and more humid.

A Peaked Hill Trust volunteer stopped by today to inspect and adjust the shack's gloriously silent propane refrigerator, which apparently has a history of running either too cold or too warm, though it has performed adequately during our stay. Propane refrigerators are unusual things, the physics of chilling by means of combustion obviously counter-intuitive. After reassembling things and declaring all was well, our visitor enquired about the ongoing roof leak situation. We pointed out the recent leak. As he was leaving, I detected a faint smell of propane's rotten egg odorant but kept that to myself, lest a corps of volunteers launch an operation in search of a leak, likely tearing the place apart and evacuating us as a precaution. This place is so far from being airtight that I am not concerned. No need to mention this to Janis either.

A roofing squad, two men both named Dave, arrived later to assess our leak situation. The cure, it was determined, would be roofing tar — a lot of it, several large tubs. There was much discussion and some consternation about the rafters being merely two-by-fours, and widely spaced to boot, and whether they would support people walking around on the roof. The happy solution was to have only one of the Daves (the considerably lighter one) climb up to do the actual work. I do appreciate the Peaked Hill staff and volunteers who maintain these shacks and provide the

rare experience I am allowed to enjoy. These isolated places demand constant and determined maintenance. The elements are harsh, with no natural protection for these simple buildings perched on foundations of constantly shifting sand.

All quiet here now with our visitors gone. Gazing offshore, I see a stately black yawl close to fifty feet in length and fitted with sails of off-white Egyptian cotton, sailing across the horizon. A yawl, in addition to the main mast, sports a cute mizzenmast stepped far aft with its boom overhanging the stern. Since that small sail, often called a jigger, can be trimmed to allow sailing without adjusting the rudder, yawls became popular with single-handed sailors, notably famed 20th century circumnavigators Harry Pidgeon and Francis Chichester. Modern self-steering devices have diminished the attraction of that feature, so my guess is this is an older boat, and with binoculars I see that it has wooden spars as well.

JULY 2. WEDNESDAY. This morning the sea is alive with whales, our first sighting of them in significant numbers since arriving. Spouts are spaced all along the horizon, hanging in the air like small clouds until they dissipate. Flocks of gulls hover over the most active spots. Frequent breaching makes these whales easy to identify as humpbacks by the shape of the dorsal fin. Their black bodies glisten as the sun catches the ocean water streaming off, making them appear momentarily striped with white. The whalewatch boats have begun steaming in, brimming with colorfully attired customers.

Whaleship Model, Woods Hole

Whale watching has been a boon to tourism, while encouraging environmental awareness, and providing a vital continuous stream of data to researchers. But the other story of whales and Cape Cod is much older, beginning with the Cape's first (and quite impressive) period of prosperity. The demand for oil, primarily from sperm whales, peaked in the first half of the 19th century, and in those years Cape Cod captains and crew members roamed the world's oceans in voyages of astonishing scope. Several of the Cape's natural harbors, like Wellfleet (originally "whale fleet"), Provincetown, and Falmouth, were well suited for large whaling vessels, but the entire area benefited from the whaling economy, much as

California did from the Gold Rush, with all the ancillary services of this major industry lifting the local economy. Captains and sailors brought great wealth ashore when they returned with their hugely valuable cargo. The world demanded illumination, and unfortunately for these noble sea mammals, New England seamen, primarily from the Cape and the Islands, along with New Bedford, possessed the bravery and talent to obtain the prized whale oil. In this regrettable irony, people worldwide — often those best educated — enjoyed their "enlightened" parlors while their ignorance allowed the cruel and relentless hunt that brought these creatures to the brink of extinction. However, we remain intrigued by the adventurous and romantic exploits of the skilled seamen, even as we deplore the whale hunt.

A familiarity with the whaling epic is valuable for appreciating the history of Cape Cod. Driving or biking along Route 6A through Cummaquid, Barnstable, and Yarmouth Port, you see the way dotted with fine captains' houses and lined with ancient trees that now closely hug the narrow road. One can explore Captain Penniman's mansion in Eastham, entering by passing through the arched gate of huge whale jawbones, an exercise believed to bring good luck. And certainly there is no substitute for reading *Moby-Dick* or Nathaniel Philbrick's *In the Heart of the Sea*.

I just returned from a late afternoon swim in some nice rolling swells, coming at one point face-to-face with a large seal. I finished reading almost all the books here. Someone must have decided to tighten things up this spring, fairly drastically as far as reading material is concerned. One volume that did survive the library purge is an 1886 London edition of Dante Gabriel Rossetti's poetical works, containing an introductory essay by his brother William. It is an oddly fitting work to find here in the dunes of Provincetown, the poet's unabashed romanticism and somewhat arch style blending well with the rustic elements of this place. I looked up Rossetti's famous "Woodspurge" elegy, a poem that tells of a humble plant's ability to restore the soul, in its own way a brilliant example of nature writing:

The wind flapp'd loose, the wind was still,
Shaken out dead from tree and hill:
I had walk'd on at the wind's will, —
I sat now, for the wind was still.

Between my knees my forehead was, —
My lips, drawn in, said not Alas!
My hair was over in the grass,
My naked ears heard the day pass.

My eyes, wide open, had the run
Of some ten weeds to fix upon;
Among those few, out of the sun,
The woodspurge flower'd, three cups in one.

From perfect grief there need not be
Wisdom or even memory:
One thing then learnt remains to me, —
The woodspurge has a cup of three.

JULY 3. THURSDAY. My research reveals these shacks in the dunes of Province-town and Truro have a fascinating and still-evolving history. The earliest iter-ations were the Massachusetts Humane Society's "charity houses," much dis-cussed and rather derided by Thoreau for their limitations, which were built to provide minimal shelter and protection for seamen who made it to shore after being shipwrecked on the treacherous bars hidden below the waters off the long eastern shore of the Cape. As they evolved in the 1800s, the charity houses, or their successors in various forms, became outposts for Yankee and Portuguese fishermen, for the United States Life-Saving Service's coast guards, and stretch-ing into the present, they became escapes and retreats, generally for those with a tendency toward the artistic. Dune shack society has been diligently researched by the Cape Cod National Seashore. My sojourn here represents an example of what ethnographer Robert Wolfe recognizes in his study as a recent "pattern of

use," that being the awarding of shack residencies for artists and other community members.

It was in the early 20th century that the shacks became closely associated with the developing artists' colony in Provincetown, becoming an outpost within an outpost for Americans following the example of European artists who sought out pastoral locales to live and work together, enjoying a physical and spiritual way of life removed from crowded cities. The art colony in Provincetown began in 1899 with the opening of Charles Webster Hawthorne's Cape Cod School of Art. By the middle of the next century, Provincetown was arguably among the most important places in the landscape of American art. Anne Lord, a local potter with deep ties to shack society, notes that "If you go into the National Gallery of Art in Washington, you'll see the majority of [American] artists will have spent some time, some of them years, some of them short periods of time, in Provincetown, Truro, and the environs, all drawn here, but especially to Provincetown."

Among the list of famous inhabitants of the dune shacks are Eugene O'Neill, e.e. cummings, Jackson Pollack, Norman Mailer, Mark Rothko, Edmund Wilson, John Dos Passos, William de Kooning, and Tennessee Williams. When the campaign to preserve the shacks against threats by a benighted Park Service needed to rebut the suspect finding of "no historical significance," it was with great excitement that a letter by Jack Kerouac was produced mentioning his writing part of *On the Road* in one of these little structures!

Ultimately recognizing the historic and cultural values of the dune shacks, the Peaked Hill Bars Historic District was created, the name referencing the Life-Saving Service (later Coast Guard) station there, for a time occupied in summers by the playwright O'Neill after its official discontinuance, and since lost to the eroding cliffs. This from the Life-Saving Service in 1872, discussing that location in inadvertently poetic language: "A more bleak or dangerous stretch of coast can hardly be found in the United States than at this station. The coast near the station rightly bears the name 'ocean graveyard.' Sunken rips stretch far out under the sea at this place, ever ready to grasp the keels of the ships that sail down upon them, and many appalling disasters have taken place here. There are two lines of bars that lie submerged off the shore . . . these bars are ever shifting." Though the

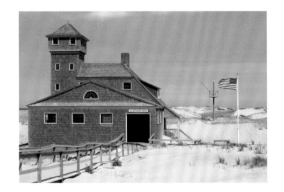

Old Harbor Station

Peaked Hill Bars Station is gone, nearby at Race Point is the similar Old Harbor Station, moved from Chatham in 1973, and worth visiting to learn about the era of the original coast guards who patrolled the hazardous long shore from Provincetown to Chatham.

The finding of eligibility for the designation of Peaked Hill Bars area as a historic district notes that the dune landscape was "the lynchpin of the district's cultural importance." The reporters go on to observe that "The dune shacks provided shelter while minimally intruding into the contemplative solitude of the environment that provided the impetus to an abundance of artistic and literary work. The shacks' unpretentious, predominantly one-room structure, the simple materials and craftsmanship, their mobility, and their lack of amenities such as electricity and running water enabled their inhabitants to experience a survivalist relationship with nature." That description applies equally and accurately today.

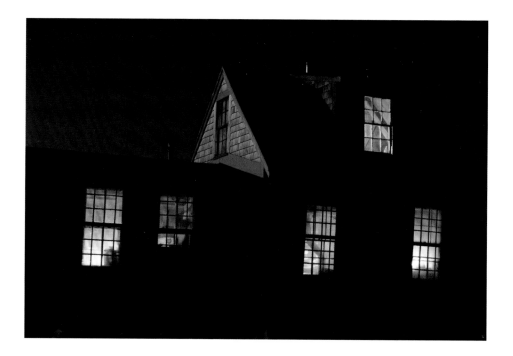

C-Scape Dune Shack by Moonlight

Simplicity

There are no sounds here except the sounds of the natural world, and life is very simple. Water is drawn from the ground by hand, after priming the pump by pouring in water while steadily and briskly pumping. Oil lamps light the cabin at night. When it is quiet, you can hear wood bees chomping away at the shingles, a reminder, as if one were necessary, of the impermanence of pretty much everything here. This is the optimal place to absorb the dizzying Transcendentalist brew of freedom and self-reliance, spiritualism, non-conformist thinking, and romanticism. Here one has no choice but to comply with the centerpiece of Thoreau's philosophy, his foundational mantra: "Simplicity, simplicity, simplicity!" I wish I could pursue my artistic calling without relying on a complex array of photographic gear, although my kit is rather modest. My current cameras and lenses are engineering marvels, and their design reflects the principle of form following function. Somehow the forms that followed the functions in my old Leicas and wooden field cameras were far more pleasing than my black Nikon with its heavy professional level lens. Janis brought along a sketchbook and a little field set of watercolors. She'll carry the simplicity banner for both of us.

A walker on the beach informed us of the impending arrival of Hurricane Arthur, due tomorrow afternoon. Ominous long slow waves are already starting to roll in from far out at sea. It looks like that roofing tar will have an opportunity to prove its mettle.

JULY 4. FRIDAY. We had hoped to see the fireworks in Provincetown Harbor from here tonight, but no doubt they have been cancelled due to the storm. It is rare to have a hurricane so early in summer, although there is not much indication of anything unusual this morning, the sky clear and sunny. We even managed to take a careful swim despite increasingly persistent wave action. A park ranger came along driving her little beach vehicle, with two smiling young female interns in tow, each on their own oversand vehicles. They were checking on the plovers and their offspring before the imminent wind and rain, and told us there were some two-day-old chicks off to the east if we wanted to look for them. We talked

in some detail about the timing of the coming storm ("expect eighty mile-per-hour winds and very impressive waves") and plover and tern behavior. The park workers moved the protective cordons landward a few yards in anticipation of the high seas, then waved as they zipped off in their colorful Mars Rovers to look in on more of their feathered charges.

By the time we climbed back up the dune, the sky had already begun to darken dramatically as the storm moved in, and in decidedly short order there was intense lashing rain. I was completely drenched after just a quick run to the pump to fill water bottles. Conditions deteriorated by the minute, and soon we could not hear each other talk amid the beating rain and wind. Any option for leaving had disappeared, and we were once again setting out the array of pots, buckets, and any other available vessels all over the floor, as the roof again began leaking.

Over the course of the afternoon, some very brief alternating stretches of dryness and even glimpses of blue sky arrived, each followed by increasingly powerful intervals of wind and rain, as the bands of the cyclonic storm continued to advance. This was likely just the beginning, according to the rangers' intelligence.

Later afternoon now, and we have gone past a mere gale and are plainly in full-on hurricane conditions. Thunder and lightning are frequent and fierce. The thunder, distant and muffled at first, is now close by. I timed the longest continuous peal at over twenty seconds. Some are of a tone so deep you feel them more than hear them, while others are massive deafeningly sharp cracks. There is still some delay between lightning and thunder, so the main energy of the storm is not fully upon us. This will be my last entry until the other side of things. Time to focus efforts now on pressing safety concerns: taping up windows, securing things as much as possible, etc. At least no need to worry about power outages. A bit scary, but I trust we will make it through as other Cape Codders have over the years. Janis is, probably wisely, a bit less confident.

JULY 5. SATURDAY. Reader, we survived! Still here and safe this morning, I am happy to report, though weathering the storm was a remarkable adventure. The conditions continued to worsen at a frightening and accelerating rate into the

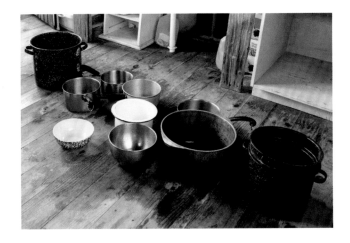

night, peaking in intensity by about two in the morning. There were constant banging sounds all through the storm. We first thought things were flying around and crashing into the house, then finally determined it must be the heavy asphalt roof shingles repeatedly lifting and crashing down on the roof, the wind each time drawing them up from the slightly sloped roof by action of the Bernoulli effect. Small consolation that conclusion was in the night, knowing that is the same force which, in addition to allowing a boat to sail up into the wind, also effortlessly lifts a million-pound 747 aircraft off the runway. Our worst fear was that the entire roof would fly off the shack, a possibility not out of the question, and perhaps it was the loosely repaired shingles that by chance averted that by dissipating some of the powerful uplifting energy. Without the roof, there would be little to hold the place together. Janis asked what the strategy was in that event, but there was no viable plan for that eventuality.

Last night we took the further precaution of nailing bed comforters over the windows to supplement the duct tape. A shower of glass was probably the likeli-est danger we needed to protect ourselves from, and there was little we could do about the roof, anyway. After that we huddled in sleeping bags — amazingly the beds were under the only dry part of the shack — with flashlights close at hand. I encouraged Janis to drift off to sleep, at last allowing myself to fall asleep when I was fairly sure that the worst had passed, and we would be OK after all. I dreamt

that all of Cape Cod was covered with water, except for our lone dune shack peeking above the waves as a last remnant. I guess things will be that way in the distant future, all this gone like once-thriving Billingsgate Island in Cape Cod Bay, to be noted on charts perhaps as Cape Cod Shoals. We awoke eagerly expecting to be greeted by one of those stunning crisp dry blue-sky days that often follow storms, but were disappointed to find the storm only grudgingly winding down with no sun in sight, the air damp and drizzly, and the restless ocean still pounding the shore. The shack of course was flooded, so we began mopping up and trying to air the place out. Oddly enough, as we explored outside, some unsecured things had hardly been disturbed at all despite the turbulence of the storm. In the morning under a gloomy sky, stalwart Boris's stood proudly intact, though its shingles were drenched and dark, almost black.

By noon there was a little sun and a drying breeze, allowing us to make the place habitable by the time the Peaked Hill folks arrived with our replacements. As we were driven back to our car, we looked out the back of the truck at the receding landscape as we had two weeks earlier, seeing little evidence of the momentous storm. Aside from a couple of small lakes in the sand road there was little indication that a Category 2 hurricane had brushed the coast a few hours before.

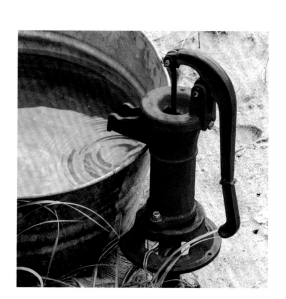

The Reliable Water Pump

Now we are back in Orleans with the storm finally past, racing north toward its demise over the cold waters of the North Atlantic. A moment ago Janis called me over to the window to witness the unusual sight of a deer swimming across Little Pleasant Bay from Sampson Island to the mainland. A seal approached it and retreated numerous times, confused by the uncommon visitor to its watery realm. As we watched, the deer progressed slowly but determinedly with only its head and the ridge of its back visible, the sunlight breaking through clouds in the distance, illuminating the thin strip of Nauset Beach that is visible from here. Taking in this view while sitting on a comfortable couch in this softer part of the Cape, I miss the little shack in Provincetown and the Zen-like repetition of going down to the sturdy bright red water pump, or of lighting the oil lamps at dusk. I expect we will wake in the night confused by our surroundings before remembering where we are, here in an exquisite corner of our little planet, on this sandy arm of land which extends into the broad and deep sea.

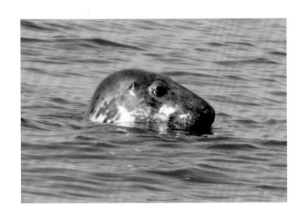

About the Author

DON KROHN is a New York City-born photographer and occasional writer, teacher, and designer. *In the South of France*, his previous book of photographs, was highly acclaimed. A graduate of Brandeis University and Harvard Law School, he also pursued studies at the University of Chicago's Committee on Social Thought. He was founder and first president of both the Cape Cod Lighthouse Charter School and the Orleans Improvement Association, and drafted Orleans' innovative architectural review bylaw. His civic activities continue with involvement in the Orleans Community Partnership and the Orleans Cultural District. As a photographer he is self-taught, traveling extensively in pursuit of his craft. He lives in Orleans, on Cape Cod, with his wife Janis Brennan. They are co-owners of Main Street Books and the Orleans Whole Food Store.

On Cape Cod was composed in Prensa types designed by Cyrus Highsmith of Providence, Rhode Island. He arrived at this family's character through his process of "wrapping outside curves around the inside, deliberately creating tension between the two," a technique epitomized in Electra, a 1935 book face by twentieth-century master W. A. Dwiggins of Hingham, Massachusetts. The display types and captions were set in Relay Wide (also by Highsmith)—and also taking inspiration from Dwiggins. Relay reaches back to the middle of the last century for inspiration, when humanist proportions and shapes were applied to the geometric sans serif and established a trend within European art deco. In the United States, C. H. Griffth and W. A. Dwiggins achieved a similar effect with Metro, influencing American lettering from the diner to the comic book to the hand-painted signs of Cape Cod.

The printing and binding are by C & C Offset of Hong Kong. The design and typography are by Michael Russem of Cambridge, Massachusetts.